EVERYTHING SINGS

EVERYTHING SINGS
MAPS FOR A NARRATIVE ATLAS

DENIS WOOD

with an introduction by Ira Glass, an interview by Blake Butler
and essays by Albert Mobilio and Ander Monson

SECOND EDITION

siglio Los Angeles 2013

Everything Sings: Maps for a Narrative Atlas © 2010 and 2013 Siglio Press and Denis Wood
All maps, visual material, and texts © Denis Wood, except as noted.

Introduction © 2010 Ira Glass; Interview © 2012 Blake Butler, originally published in a shorter form in *The Believer*, January 2012; "Everything's Rings," "Everything's Signed," and "For an Odd Geographer" © 2013 Ander Monson; "In the Heights" © 2013 Albert Mobilio; Artwork from *Une semaine de bonté* by Max Ernst © Artists Rights Society, New York/ADAGP, Paris; "Wanderbewegung wichtiger Länder" by Otto Neurath in *Gesellschaft and Wirtschaft*, Bibliographisches Institut AG, Leipzig, 1930, image courtesy of Otto and Marie Neurath Isotype Collection, Department of Typography & Graphic Communication, University of Reading, UK; image from "Buffet" by Georges Ribemont-Dessaignes in *Litterature* No. 19, 1921, image courtesy of the International Dada Archive, Special Collections, University of Iowa Libraries; excerpt from "Orange Bears" © Kenneth Patchen, from *Red Wine and Yellow Hair*, New Directions, 1949.

All rights reserved. No part of this book may be transmitted or reproduced in any manner or form without permission in writing from the copyright holders. (The Jack-O'-Lanterns map is a Creative Commons image and may be freely reproduced with attribution to Denis Wood.)

Editor: Lisa Pearson
Cover and book design: Natalie Kraft
Siglio Intern: Niyati Shenoy
Cover image: Jack-O'Lanterns
Frontispiece and last page: grids of details from selected *Everything Sings* maps

SECOND EDITION
ISBN: 978-1-938221-02-6
Printed in China

siglio

uncommon books at the intersection of art & literature

www.sigliopress.com
2432 Medlow Avenue, Los Angeles, CA 90041
publisher@sigliopress.com

Distributed to the trade by Artbook/D.A.P.
155 Sixth Avenue, 2nd Floor, New York, NY 10013
p: 800-338-2665

TABLE OF CONTENTS

Introduction by Ira Glass	10
Everything Sings by Denis Wood	12

Maps for a Narrative Atlas

WHERE IS BOYLAN HEIGHTS?	20
AUNT MARIE'S MAP	25
THE NIGHT SKY	34
NESTING	36
BOYLAN'S HILL	38
INTRUSIONS UNDER HILL	40
SQUIRREL HIGHWAYS	42
TREES IN GENERAL	44
BROKEN CANOPY	46
AERIAL VIEW	48
DISFIGURED TREES	50
POOLS OF LIGHT	52
STREETS	54
FOOTPRINTS	56
SIGNS FOR STRANGERS	58
POLICE CALLS	60
NUMBERS	62
MAILMAN	64
LESTER'S PAPER ROUTE IN SPACE & TIME	66
TWO ROUTES	68
THE PAPER'S ROUTE	70
ALLEY WAYS	72
BUS BALLET	74
RHYTHM OF THE SUN	76
THE LIGHT AT NIGHT ON CUTLER STREET	78
ABSENTEE LANDLORDS	80

LOCAL RENTS	82
FAMILIES	84
ASSESSED VALUE	86
NEWSLETTER PROMINENCE	88
JACK-O'-LANTERNS	90
PUBLIC & PRIVATE TREES	92
FENCES	94
ROOF LINES	96
SHOTGUN, BUNGALOW, MANSION	98
STORIES	100
SIDEWALK GRAFFITI	102
WORDS	104
A SOUND WALK	106
WIND CHIMES	108
RADIO WAVES	110
BARKING DOGS	112
DOGS	114
VIEWSHEDS	116
FLOWERING TREES	118
AUTUMN LEAVES	120
THE AGE OF TREES	122
TREES BY SIZE	124
THE MAGIC TREE MAP TRANSFORMER MACHINE	126
Interview with Denis Wood by Blake Butler	130
In the Heights by Albert Mobilio	136
Everything Sings Triptych by Ander Monson	140
Appendix	144
Acknowledgements	149

INTRODUCTION IRA GLASS

When I encountered these maps of Boylan Heights years ago, what I first loved was how impractical they were. Most maps are entirely about doing a job. They are dull salarymen who clock in early and spend their days telling you where stuff is with unrelenting precision. They never vary an inch from these appointed rounds.

Not these maps. One of my favorites, Pools of Light, is a dreamy rendering in blurry white circles of the light cast by street lamps. Even if you were in Boylan Heights on a dark night and badly needed to find a street lamp, it's hard to imagine how this map would help you. For one thing, you'd need to get under a street lamp to read the damn map, and once you'd accomplished that, well, you'd have achieved your goal, wouldn't you?

Granted, the map that's dotted with jack-o'-lanterns indicating which houses set them out for Halloween—another favorite—could conceivably be a guide for neighborhood toughs on an unusually thorough smashing binge. But how likely is that? What kind of ten-year-olds would have the impulse to kick in a few pumpkins and also have enough of an OCDish drive to decimate every single one that they'd consult a map?

These maps are completely unnecessary. The world didn't ask for them. They aid no navigation or civic-minded purpose. They're just for pleasure. They laugh at the stupid Google map I consult five times a day on my phone. They laugh at what a square that map is. At its small-mindedness. They know it's a sad, workaholic salaryman.

Their mission is more novelistic. Which I also love. What they chart isn't Boylan Heights exactly but Wood's feelings about Boylan Heights, his curiosity about it, and his sense of wonder at all the things about the place that are overlooked and unnamed.

That a cartographer could set out on a mission that's so emotional, so personal, so idiosyncratic, was news to me. It reminds me of how a recent generation of comic book artists turned that hack medium of superhero adventures into a medium of

novelistic stories drenched in feeling and personality. It reminds me of all the bloggers and tumblrs and tweeters who've taken a global computer network designed for engineers and the defense establishment and transformed it into their noisy, messy clubhouse.

And these maps remind me of all the radio stories I love most. After all, radio is mostly a boring salaryman, waking up before you and me to announce the headlines or play the hits to some predetermined demographic. Yet some radio stories elbow their way into the world in defiance of that unrelentingly practical mission, with the same goal Denis Wood's maps have: to take a form that's not intended for feeling or mystery and make it breathe with human life.

Which brings me to the oddest thing about these maps. They describe human lives without ever showing us any people. Instead, we see the underground structures that humans build for waste and the paths they make for squirrels in the sky. We see which homes have wind chimes and which ones call the cops. We see the route of the letter carrier and the life cycle of the daily paper. Wood is writing a novel where we never meet the main characters, but their stuff is everywhere. I don't know exactly how to describe the feeling that creates. It's like walking around a world that's been decimated by a neutron bomb and walking into all the houses. You miss the people who lived here, and you think about their daily routines. You can count the scraps of toast left on their plates and smell the bacon they were preparing right before they were vaporized. Their lives seem far away and utterly present, both at the same time. Which somehow makes our world seem fragile and very precious. Maybe it's just me, but that seems like the opposite of the feeling ordinary maps give us, with their rock solid facts and their obsession with street names. They make the world seem anything but fragile.

Though, of course, the world is fragile. And fleeting. And so Denis Wood's maps are a far more accurate depiction of Boylan Heights than any normal map could ever hope to be.

EVERYTHING SINGS DENIS WOOD

Gerardus Mercator called his great work of 1595—from which our contemporary use of "atlas" to describe a collection of maps is derived—*Atlas sive cosmographicæ meditationes de fabrica mundi et fabricati figura*, which might be translated as *Atlas, or Cosmographic Meditations on the Fabric of the World and the Figure of the Fabrick'd*. Maps were only a part of what Mercator had intended as a cosmographical meditation of encyclopedic proportions: the creation of the universe, ancient and modern geographies, the histories of states, a universal chronology. In Mercator's vision, "Atlas" encompassed . . . *everything*.

But William Blake had a different vision:

> To see a world in a grain of sand,
> And a heaven in a wild flower;
> Hold infinity in the palm of your hand,
> And eternity in an hour.

So did Henry David Thoreau:

> The world is never the less beautiful though
> viewed through a chink or knot-hole.

Happy thought: have it both ways, a meditation on the cosmos—and in map form—but the cosmos as seen through the knot-hole of a neighborhood! Something on that scale might even be doable. And

why not? Why not an atlas of a neighborhood that you could read as if it were, say, a novel by Balzac (*Illusions perdues* perhaps or *Cousin Bette*), an atlas rooted in a profound sense of place, larded with moral ambiguity, stuffed with richly human characters, rife with incident, and . . . ah, well, maybe not all that!

The Atlas and the Narrative

And yet . . . *why not?* Every map has its own tale to tell. Linking maps into a narrative atlas should transmute the maps into something like *The Canterbury Tales,* like the entire cycle of Balzac's *Comédie humaine.* Well, no need to go overboard. But it has been precisely a failure of ambition that for years—for centuries!—has stunted the atlas, kept it from achieving the signifying comprehensiveness of which Mercator dreamt. It's not that atlases don't have an inherent narrative thread. If you run maps in a sequence, people are bound to make meaning of the order. It's harder than one might imagine to sequence things without making meaning. So it's less an absence than a self-conscious *denial* of narrativity that's gagged the atlas's narrative voice. It's been claimed—again, for centuries!—that atlases are works of reference, where you go to find facts, facts you *need*. Consult an atlas, find your fact (fast), reshelve the atlas. Do not read it, certainly do not read it cover to cover like a novel. What an amusing idea, *reading* an atlas, with its forbidding style of clipped sentences devoid of anecdotes, elaborations, and by-the-ways.

> "Just the facts, ma'am."
> "Please answer the question, yes or no."

As though anything were ever so simple.

Yet this is one way maps maintain the illusion of their objectivity, their adherence to the factual. Admitting that atlases were narrative—that they were *texts*—would force the admission that the individual maps were texts too, that maps constituted a semiological system indistinguishable from other semiological systems, like those of paintings or novels or poems.

The map as poem: this is something maps have labored to deny from the beginning.

Critical to this denial was the evolution of a literal panoply of technical map signage. The north arrows, scale bars, and other specialized symbols served to isolate the map from graphics such as prints, which were likely to emanate from the same workshop. Mapmakers were unquestionably responsible for this development, but also complicit were the commercial interests involved in map production and distribution, the legal and bureaucratic apparatuses that depended on maps, the academic disciplines invested in maps as a form of knowledge—a very special form of knowledge—and the governments that, from the sixteenth century on, have exploited the power of maps for ever-widening administrative purposes; that is, all those with a vested interest in the belief that maps are "Just the facts, ma'am."

A lot rides on the facticity of the map.

To deny any continuity with painting and printmaking, stress "scientific" measurement, stress ever greater "accuracy;" when gathering maps into atlases, stress systematic order—the alphabetical, the gridded—to deny any continuity with narrative. This renders the atlas nothing more than a way of keeping the maps piled on the table from slipping to the floor.

The problem is none of this works. What comes first is always primal, typically causal. Roland Barthes said, "Everything suggests, indeed, that the mainspring of narrative is precisely the confusion of consecution and consequence, what comes *after* being read in narrative as what *is caused by*," and in atlases this is generally the case. Does anybody doubt an essay is being written through the sequence of world maps

that opens a typical student atlas: political, physical, climate, natural vegetation, soils, agriculture, population density, gross national product, literacy, protein consumption, and life expectancy? If not a cosmographical meditation on the creation of the universe, certainly an environmental-determinist disquisition on the origins of poverty! Can this be doubted?

Of course, this threatens our ability to accept the independence of the maps. We begin to see that they are servants of *this* way of thinking as opposed to *that*, they're involved in story-telling, they're not compendia of facts. This is why any intentionality in the ordering is so ferociously denied: the map essay on the causes of poverty that pretends not to be an essay at all is a uniquely powerful way to naturalize poverty. It suggests that poverty arises naturally from the earth itself, that there is nothing we can do about it. This is the power of what Barthes called myth.

So the ever-returning question: "What order would you have put them in?" Without doubting for a second that most atlases have always been ordered to promote one reading at the expense of another, I don't think it matters. *Any* order will give rise to a narrative reading which will—it's the nature of reading—be imputed to the subject. (Whence the power of writing arises, the power of all claims-making.) Resisting this was a major concern for 20th century artists: Marcel Duchamp letting his threads fall as they would ("If a straight horizontal thread one meter long falls from a height of one meter onto a horizontal plane twisting *as it pleases* [it] creates a new image of the unit of length"), Max Ernst unraveling existing narratives in his collages, Óscar Domínguez and Remedios Varo rubbing wet paint surfaces together (Domínguez called it "decalcomania with no preconceived object"), John Cage consulting the *I Ching*.

As with atlases, every sequence *insists* on some kind of meaning, imposes some kind of signifying experience. Cage is a wonderful

from *Une semaine de bonté (quatrième cahier: mercredi)* by Max Ernst, Editions Jean Bucher, Paris, 1934.
© 2010 Artists Rights Society (ARS), New York / ADAGP, Paris

example. He worked so hard to build chance into his work in an endless effort to free the work from himself, from his own taste, from his personal preferences (his preferred principles of order). There was his prepared piano with its nuts and bolts, the *I Ching* with its tossed coins, the pitches from star charts, the mesostics on Thoreau and Joyce (the fabulous *Roaratorio, an Irish Circus on Finnegans Wake*). Yet no matter what he tried, in the end melody reasserted itself. Cage was fond of quoting Christian Brown: "No matter what we do it ends by being melodic." I'm not sure I find this quite the cause for regret that Cage and Brown did. I too like noises—I love them!—but I also like melody. And while I agree with Cage that "humanity and nature, not separate, are in this world together, that nothing was lost when everything was given away," to me this also means that melody is here too, a perfectly organic melody which, with regard to atlases, is to say: narrative.

Denied by science, resisted by modern art, the narrative reading is inescapable. *Make the most of it!* After all, objectivity does not consist in suppressing an unavoidable subjectivity. It is achieved by acknowledging its intrusion so that the reader is relieved of the necessity of ferreting it out. Besides, nothing obligates a reader to start at the beginning and plow through the complicating actions to the resolution. A reader can always enter an atlas anywhere, via the index or the table of contents or, like Tommy Stubbins, with his eyes shut, letting the atlas fall open where it will, stabbing it with a pencil to fix the destination of Dr. Doolittle's next voyage.

The Map and the Poem

Imagine an atlas with a structure ordered to tell a story greater than those told by each individual map, an atlas with something more clearly on its mind than keeping the maps off the floor. There are terrific examples of narrative atlases, *self-consciously* narrative in precisely the way I'm advocating. The series inaugurated by Michael Kidron and Ronald Segal—*The State of the World Atlas, The New State of the World Atlas*, and so on—is especially exemplary. Below the title of each of their maps is a pithy, almost aphoristic, verbal summary of its point. This effectively and immediately removes the maps from the class of reference works (a reference map may have a subject, it cannot have a point) and encourages reading the maps as links in a chain of argument. The sharply pointed quality of the captions makes it clear to even the most obtuse reader that this atlas is not a hodgepodge of "neutral" maps but a lively polemic about a self-perpetuating system of sovereign states so preoccupied with aggrandizement and conflict as to lead to world cataclysm. The sharpness of tone promotes close attention to the maps (if only in search of alternate readings). The concision propels readers to the explanatory notes (which explicitly discuss the quality of the data). It soon becomes apparent that the plates build on each other, that the divisions of the atlas have a rhetorical—not arbitrary—basis, that the notes are vital to any deep understanding of the maps. It is clear that the atlas is declaring itself an essay on the destructive potential of the nation-state. Nothing but an atlas could have accomplished this with equal force. Bill Bunge's *The Nuclear War Atlas* and the series of historical atlases Colin McEvedy made for Penguin are other examples (McEvedy opened his *Penguin Atlas of African History* with, "What it is not intended to be is a reference atlas").

These atlases further distinguish themselves with maps that are essentially modern, and I do mean "Modern." Given the ubiquity of Modernism, it is astonishing that it laid so light a glove on mapmaking. Yet as Modernism was noisily turning its back on the failed rationalities, empty harmonies, and make-believe coherences of both Enlightenment and Victorian thinking, cartography was clutching them ever more tightly to its breast. Painters may have been deconstructing pictorial space, composers shredding inherited tonalities,

(above) from *Gesellshaft und Wirtschaft*, illustration by Otto Neurath, Bibliographisches Institut AG, Leipzig, 1930. Otto and Marie Neurath Isotype Collection, University of Reading

(right) from "Buffet" by Georges Ribemont-Dessaignes in *Litterature* No. 19, 1921. International Dada Archive, Special Collections, University of Iowa Libraries

architects stripping walls of pilasters, cornices, and dentil moldings, poets following Pound's cry to "Make it new," and novelists indulging a self-consciousness that was all but the hallmark of the age, but cartographers were content to hone, polish, and extend inherited forms. Cartography exalted its unreflective empiricism as its *raison d'être* and cherished the graphic conventions it had laid down in the 19th century. Even today few maps acknowledge the 19th century's gone.

Exceptions, such as Otto Neurath's Isotype maps, came from outside the profession. Neurath was a Vienna Circle polymath—a philosopher, originally a political economist—who, as director of the Social and Economic Museum of Vienna, developed a way to describe social, technological, biological, and historical phenomena in a "world language without words," a kind of pictographics he called Isotype (International System of TYpographic Picture Education). I know you've seen these: phalanxes of identical little men or cars or cows, all in poster colors, arranged to form graphs. Reductive minimalism. Stripped down. Almost aggressively modern. Sans serif typefaces (Akzidenz-Grotesk). There were Isotype maps too, and through Neurath's visits, Soviet mapmaking acquired a modern accent missing in other traditions. Harry Beck's map of the London Underground is a better known example.

But Beck and Neurath are exceptions that prove the rule. Look at Herbert Bayer and his *World Geo-Graphic Atlas*. Bayer was an archetypic Bauhaus designer—he both studied and taught there—with a distinguished U.S. career as an iconic modernist. His atlas, commissioned by the Container Corporation of America as a corporate giveaway, may very well be the "benchmark for information graphics that has yet to be equaled" that it is so often claimed to be. Its self-consciously narrative orchestration of double-page spreads of information-rich graphics opposite maps has proved lastingly influential. Yet the maps themselves were literally off-the-shelf, commercial products of the most pedestrian variety (the maps of the U.S. came from Rand-McNally). There

was nothing remotely modern about them. They were, in fact, relics of 19th century design. It was as though the map were protected by an impenetrable carapace of reference work authority, an aura that kept the designer's hands off: he could work around it, he could not touch.

Well, of course, he couldn't! He wasn't a cartographer, not a professional cartographer! *Only* a cartographer can make a map! Or so the cartographers would like you to believe. But then Neurath wasn't a cartographer either, and Beck was an engineering draftsman. For that matter, Mike Kidron was a Marxist economist; Ronald Segal an anti-apartheid activist, writer and editor; and Colin McEvedy a psychiatrist. Why were all these non-professional mapmakers making maps? Because cartographers couldn't or wouldn't make the maps they needed, because cartography refused to make the leap into the 20th century.

As a graduate student in geography studying cartography, this all made me very queasy. It was the 1960s. I was listening to Stravinsky and Cage and Smokey Robinson and the Beatles. I was looking at de Kooning and Jim Dine and David Hockney. I was protesting the war and resisting the draft. Geography as an academic discipline was determinedly ignoring Vietnam, civil rights, and feminism. It knew little of Marx, nothing of Foucault, and it seemed content to pump out papers like "Vacation Homes in the Northeastern United States: Seasonality in Population Distribution" and "The Changing Status of New Zealand Seaports, 1853-1960." Cartography was even worse, taught as a craft with vellum, bow compasses, quill pens, and Leroy lettering templates. What the fuck *was* all this antique shit!? I quickly tired of dot distribution maps of Kansas hogs—a map so often seen it was turned into a joke tee-shirt—but I was also exhausted by the recruitment of university-trained mapmakers into what was then the U.S. Army Map Service to make maps of targets for U.S. bombers.

The line between the hog mapping and the target mapping was short and direct, a kind of repulsive instrumentalism to which Modernism, as I understood it, was irrevocably opposed (Dada, Surrealism, Gerrit Rietveld, Kurt Weill and Bertolt Brecht, Situationism, concrete poetry, New Wave film, you name it). Modernism came with a predisposition for resistance and smashing traditional forms, for going someplace stripped down, essential, real, for asking, *Why not?* Already in graduate school I was feeling around for a new map that wasn't of the same old subjects, that didn't have the same old forms, that looked and felt *modern*. Schoenberg wanted to emancipate the dissonance. Arp wanted to destroy existing modes of art production to counteract "the trumpets, the flags and money, through which repeatedly killings of millions were organized on the field of honor." And I wanted to destroy existing modes of mapmaking through which millions were repeatedly killed. I wanted to emancipate dream and desire as subjects of the map.

What a delirium!

Looking for a job in geography was disheartening. There was zero interest in hiring someone like me (my dissertation was entitled *I Don't Want To, But I Will*), substantially less than zero when it came to cartography. All they wanted was a technician, someone to keep the cartography lab running smoothly while completing enough research to satisfy the provost when it came to promotion

("Group and Individual Variations in Judgment and Their Relevance to the Scaling of Graduated Circles"). Mapmaking was understood as a trade or as a fee-for-service profession: the neutral, unbiased, value-free provision of maps for employers or clients who wanted to bomb the land, mine it, drill it for oil, run roads across it, plant suburban subdivisions on it, promote it as a tourist destination, or buy and sell it. Love it? Don't talk to the cartographers, talk to the poets. What if map-making were an expressive art, a way of coming to terms with place, with the experience of place, with the love of place?

When I talked about these things at the obligatory faculty-student colloquia, I was met with blank stares (*What is this madman talking about?!*) and no job offers: "It will not come as a surprise to you to learn that we are not offering you a position on our faculty. Indeed, it did not seem to us that you wanted one."

Indeed, I didn't.

In 1974 I ended up at North Carolina State University in Raleigh teaching environmental perception to landscape architecture students. I used mapping as a way of selectively focusing their attention on those aspects of the landscape that, in the instrumentality of *their* training as future professionals (at least they were open about it), they were apt to overlook: the way the land smelled, the way it felt in their legs when they walked it, the sound of the wind in the oaks after all the other leaves had fallen, the way twilight made all the difference. At least this was all *useless* knowledge—nothing a developer or a bank could monetize—and the maps were fun to make. And because landscape architecture students are design students, there was both an attention to polish and an imaginative drive to find the less "mappable" things that, from the beginning, set their work apart from that of cartography students who were more concerned with "getting it right."

Even so, I couldn't get them to leave the streets off their maps.

As they mapped the nearby neighborhoods—Cameron Village, Cameron Park, Deveraux, Brooklyn Heights, and Boylan Heights—the streets seemed to be the irreducible subject, the what-it-was that made neighborhoods neighborhoods. If you're laying out subdivisions, as many of these students would end up doing professionally, streets really are all you have to play with, which is exactly why I was all the more eager to get rid of them. The streets seemed to inhibit the other qualities to which I was trying to draw their attention. The streets always emerged in the foreground no matter how far into the background you intended them to recede.

Then in 1982 we were working on Boylan Heights, on a whole *atlas* of Boylan Heights, specifically a map of street lights, and we began paring away the inessential, the map crap (the neat line, the scale, the north arrow), the neighborhood boundaries, the topography, finally the streets: first the scaled streets, then a schematic grid of the streets, and finally, even a hint of a grid of the streets. Daylight went too—that default daylight that most maps take for granted—so that we were fooling around with circles of white on a black background. It became clear that the map wasn't about the lamp *posts*, but about the lamp *light*, and light was something we weren't sure how to deal with. Certainly, the uniform white circles we'd been drawing caught nothing of the way the light was fringed at the edges, and one night, armed with a camera, we scaled a fence and climbed a radio tower on the edge of Boylan Heights hoping to catch the night lights on film. What a disappointment! The view from above was *nothing* like walking in and out of the pools of dappled light on the streets below. But I had a pochoir brush at home, and when Carter Crawford—who'd put himself in charge of atlas graphics—used it to draw the circles, it was magical.

That was the way it felt to be walking the streets at night!

Nothing but blotches of white. The usual "efficient" map would have located everything on the street onto a single sheet—that is, different marks for lamp posts, fire hydrants, street signs, trees. Our *inefficient* map concentrated on a single subject, and, rather than lamp posts, it brought the pools of light into view. No legend, no north arrow, no neat line, none of the usual apparatus. At last, a modernist feel! Maybe even a sense of poetry, something imagistic, a little like Pound's "The apparition of these faces in the crowd;/Petals on a wet, black bough;" or Williams's red wheelbarrow, but as it might manifest in a map, a map attentive to the experience of place.

That's when I knew we could write poems in maps, and I began thinking seriously about a poetics of cartography.

The Atlas and the Neighborhood

I don't know exactly what I mean by a poetics of cartography, but the phrase wants to capture something about the way a certain poetic specificity manages to resonate. I'd never known Kenneth Patchen's orange bears—my bears were brown—but I still cried the first time I heard him read the poem:

> The orange bears with soft friendly eyes
> Who played with me when I was ten,
> Christ, before I left home they'd had
> Their paws smashed in the rolls, their backs
> Seared by hot slag, their soft trusting
> Bellies kicked in, their tongues ripped
> Out, and I went down through the woods
> To the smelly crick with Whitman
> In the Haldeman-Julius edition,
> And I just sat there worrying my thumbnail
> Into the cover — What did he know about
> Orange bears with their coats all stunk up with
> > soft coal

What resonates is *those* bears, *their* coats, *that* edition. I imagined that if maps could achieve anything like that, if maps were to resonate like a poem, then you'd have to give up mapping pumpkins and map *that* pumpkin, stop mapping lamp posts and map *those* pools of light. Maybe that's not how it works, but I refuse to believe maps can't achieve a resonance—okay, maybe not Patchen's resonance, but some resonance—and can't the resonances of a bunch of maps make, I don't know, a heavenly chord?

Which in the end was what Mercator was after. Or something like it. Only he thought you had to cram everything in to make it work. I'm wagering Blake and Thoreau had the right of it (and Patchen and Williams and even lunatic Pound). You can make it work with anything real.

And Boylan Heights was *definitely* real.

The question was, what was it? This might seem to have been straightforward, but in coming to grips with place, delineation is often the thing you're grappling with first and last. With Boylan Heights it wasn't so difficult. In those days there were two good-sized, decorative signs at the neighborhood's most obvious entrances. In the south there was one where Western Boulevard—squeezed between Central Prison and the mental hospital—became Dorothea Drive as it swooped around the neighborhood, and there was one in the north where Boylan Avenue expanded after the constriction of the old Warren truss that used to carry the avenue across the railroad tracks. These were all unmistakable landmarks. Central Prison was North Carolina's maximum security prison for men. A classic 19th century prison—castellated, giant ashlars (construction dating to 1870)—Central was already

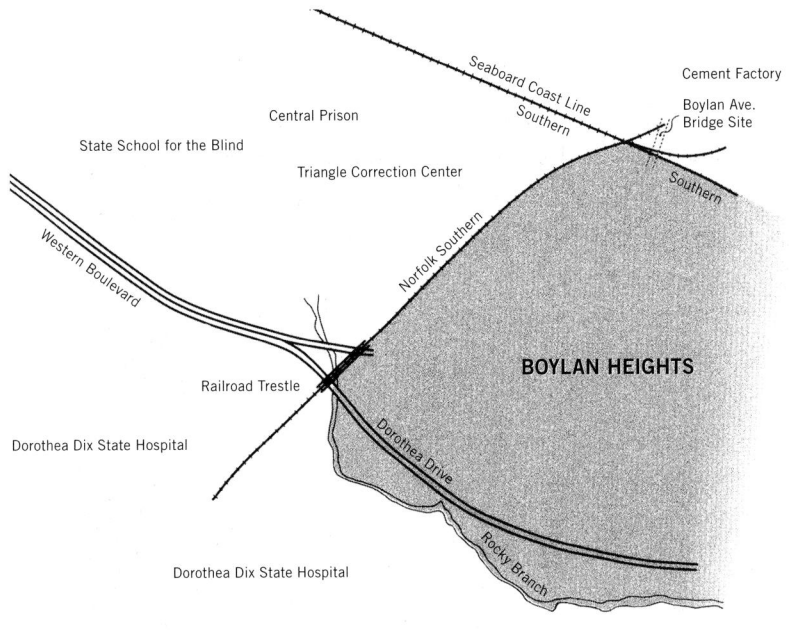

Where is Boylan Heights?

expanding beyond its old walls (it's still expanding today), housing the state's death row and better than a thousand inmates. In 1975 there was still a minimum security satellite, Triangle Correction Center, jammed in between Central and the neighborhood. West of the prison was the state's School for the Blind, founded in 1845. Even without the Norfolk & Southern railroad spur that cut between the neighborhood and the prison, the western edge of Boylan Heights was sharply drawn.

It was the same to the south. There Dorothea Dix, the state's central psychiatric hospital, spread its 2,300 acres up, across, and down the backside of Dix Hill. If you headed south out of Boylan Heights and crossed Dorothea Drive and Rocky Branch, you could walk for miles on state land, first on the hospital grounds, then on the experimental farms of the university. In the north there were railroad tracks, the ones Boylan Avenue crossed on the Warren truss. The Southern line and what was then the Seaboard Coastline's (now CSX's) main New York-Miami line joined right below the bridge where they intersected with the Norfolk & Southern tracks (that ran south to Wilmington). In a switch house beside the bridge, an actual human being manually threw the switches, pulling beautifully-tooled wooden handles as Amtrak's Silver Star and a dozen freights a day hurtled past.

Only in the east was the question of the boundary open, and probably only since Gas House Creek had been culverted along most of its length. On older maps it's almost as hard an edge as Rocky Branch. Even in 1975, the houses on the east side of the creek still came from one world and those on the west from another.

This is one way of thinking about Boylan Heights, as a place in Raleigh, North Carolina, bounded by a prison and an insane asylum and some railroad tracks and a little creek. But there were other ways of thinking about it too. You could think about it as a neighborhood, that is, as some sort of community, or as a marriage of community and place, or as *those* people in *that* place, *their* relationships, and *their* ways in the world; and thus, less a place than a process, a life process, a metabolic one. That would take an atlas to unravel: what a neighborhood is, what a neighborhood does, how a neighborhood works.

Then there was Boylan Heights itself, a particular, unique instantiation of a neighborhood with its own unfolding, its own historical circumstances. No doubt the history of Boylan Heights could be embedded in a general history of neighborhoods, but it was also embedded in the history of Raleigh, of North Carolina, of the South, of the United States, and so it was unlikely to be the same thing. That particular history, too, could take an atlas to unfold.

In doing so it would have to catch up the histories of the individuals out of whose life stories it was woven, my own, for instance, for on taking up my position at North Carolina State, Boylan Heights

was where Ingrid, then my wife, and I had landed. Talking to my dad a couple of days later, I discovered that, quite serendipitously, Ingrid and I had moved into a neighborhood where my father and his family had lived back in the 1920s which meant—*mirabile dictu!*—that our sons would be the fourth generation of their family to live in Boylan Heights. I doubted anyone else could claim that. For a mapmaker like me who'd mapped everywhere he'd lived—Cleveland Heights, San Cristóbal de las Casas, Barranquitas, Worcester—this too was an irresistible subject for an atlas. I envisioned a sequence of maps paralleling the movements of the Iroquoian-speaking Tuscaroras, first into the eastern Piedmont and then in the early 18th century north to New York; the movements of my ancestors out of the Lower Palatinate and Anglo-Celtic highlands to Philadelphia and so down the Shenandoah and Blue Ridge front into North Carolina; and the movements of the Africans shipped in shackles from the Maison des Esclaves on the Île de Gorée in Sénégal to the West Indies, thence north to Wilmington, and so up the river into the Piedmont. Boylan Heights: Tuscaroran, Anglo-German, African.

Let me hasten to say that, by no means, has all of this made it into the book you're holding in your hands. It hasn't made it into any book. The project's not done. It may never be finished. What you're holding is a piece of a dream—maps *for* a narrative atlas, not the narrative atlas itself—but it is this dream that has driven the mapmaking and that infuses the maps with whatever quality they may possess. These three threads—of neighborhood, Boylan Heights, and the Wood family—began to twist themselves into an atlas that I, at least, keep thinking about as an epic poem whose structure would shoulder the burden of its argument. *This* has made it into the book you're holding in your hands: a collection of maps as a poem, or perhaps fragments of a much longer poem out of which a passable semblance of the whole has been reconstructed.

The Neighborhood and the Transformer

The idea is this: the neighborhood is a process, a process-place or a process-thing, that transforms anywhere into *here*, and here into everywhere, the city into the space of our lives, the citizen into the individual, and *vice versa*. Correspondingly, the atlas is organized in three phases which insensibly lead from one to the other. The first embodies the neighborhood's everywhere and anywhere quality, its *continuity* with the rest of the city; the second its character as a *transformer*, literally turning city stuff into neighborhood stuff (and vice versa); the third its irreducible uniqueness, its *discreteness* in the city. The first and third phases reflect each other through the transformer acting on them, so that if in the first phase the hill the neighborhood tumbles down is presented as a fact of geology (Boylan's Hill), in the third it shows up as the slopes the kids sled down in the snow (but we're missing the sledding map fragment); or if in the first phase the neighborhood trees are just a part of the downtown Raleigh forest (Broken Canopy), in the third they acquire individuality, such as the superlative water oak at 901 South Street (The Magic Tree Map Transformer Machine).

The maps and the text are at once very personal and yet essentially abstract. While the atlas is very much about Boylan Heights, it's also about any neighborhood anywhere. They are *maps* with all of the science and technology that this implies, yet they have fingerprints all over them. I don't know where it comes from, but they have heart.

But then neighborhoods have heart, and it's that heart the maps in sequence sing about. When you look really hard at a neighborhood, it's impossible to miss how uncertain its edges are. This is because neighborhoods aren't about being distinctive, or rather, they're not *especially* about being distinctive. The most important thing about neighborhoods is how similar to the rest of the city they are, how undifferentiated, how ordinary (Numbers). Neighborhoods are part of the city. They're most of it. What neighborhoods do is make the city real. They transform the common, ordinary stuff of the city—water and sewer (Intrusions under Hill), electricity (Squirrel Highways), streets (Streets)—into the real stuff of our lives. This is the part the neighborhood plays in the life of the city, the part of a Proteus capable of turning a perfectly ordinary lamp post (Pools of Light) or crab apple tree (Flowering Trees) or stretch of sidewalk (Sidewalk Graffiti) into *that* power pole whose cables hum and sing at night as you fall asleep, *that* crab apple beneath which you played as a child, *that* stretch of sidewalk in which your kids wrote their names while the concrete was still wet. It transforms the stars that shine on everyone alike into the stars that *you* wish on (The Night Sky).

If this weren't such an ordinary, everyday thing, you'd think it was magic, but it's just the transformation of the impossible, inaccessible space of the city into the possible, accessible space in which you live; the transformation of the city as a whole—the abstracted "too many miles, too many people"—into you, into me, into us. (From the other side, of course, *we* are the "too many people.")

An electrical transformer makes a perfect metaphor. A transformer, like those gray cylindrical things you see on power poles, transforms electrical energy from a lower to a higher voltage, or vice versa. Inside the transformer are two coils. A current in the incoming "primary winding" induces a current in the outgoing "secondary winding." By varying the number of turns in the coils, the incoming voltage can be stepped up—as it is before being sent out to the grid—or stepped down—as it is before entering your house.

Neighborhoods do exactly the same thing. They transform people and things coming in from the outside (sunlight, electricity, gas, food) into neighbors and neighborhood things ("Good morning!", a shared cup of coffee, a muffin to go with it). In the same way, what's *of* the neighborhood is transformed into outside stuff, city stuff, state stuff,

nation stuff: the kid in the house next door is turned into a student at a certain school, into a citizen, a voter (Nesting). This is what I mean by "*process*-thing." Sure, a neighborhood's a *thing* (or it's a collection of things) but it's also a process, an ongoing commingling of regular routines (Bus Ballet) that slowly shift over time, accumulating history.

A neighborhood also has rhythms. Our maps are aware of the seasons (Autumn Leaves), but they're also aware of the weather (Rhythm of the Sun). They're aware of day (most of the maps) and night (The Night Sky, Pools of Light, The Light at Night on Cutler Street, Jack-O'-Lanterns), but they're also aware of the mailman on his daily rounds (Mailman) and the paperboy on his (Lester's Paper Route in Space & Time). They're aware of a single copy of the *Raleigh Times*, as they map its route into the neighborhood in the back of the route manager's truck (Two Routes); as it passes through the neighborhood in Lester's bag as he rides his bicycle; as it lands in the Poole family yard, is picked up, read, and then discarded in the trash; and, finally, as it leaves the neighborhood in the garbage truck that trundles it off to the county landfill (The Paper's Route). The neighborhood transforms the paper from a copy of the *Raleigh Times* into trash. En route, it generates conversation.

Rhythms like this beat at the *heart* of the neighborhood transformer where the power of the metaphor is particularly strong. The incoming paper snaking through the neighborhood can be likened to the primary winding, the paper lumbering off in the garbage truck to the secondary. The milkman, the vegetable man, the mailman, the delivery trucks, the school and city buses (Bus Ballet), all are involved in bringing in stuff that, sooner or later, invariably transformed, has to leave (though here the map fragments of these other routes are missing). But gas lines do this too (Intrusions under Hill). They bring gas all the way from Texas to stoves, to water heaters, to furnaces in the neighborhood. The secondary coil here is harder to see as the waste heat is vented or lost through the roof, billowing up from the neighborhood in convection clouds of warm air (we're missing the map of the heat rising from the neighborhood). In the gap between these coils? A cup of tea or a hot bath. The neighborhood inhales and exhales. It breathes.

As in a body, all these rhythms are nested. Those in the electrical transformers scattered around the neighborhood (Squirrel Highways) take place at the speed of light (you can hear them humming). The migration of kids to school takes place daily, though it also has a weekly beat and an even wider seasonal one (but these maps are missing). The pumpkins are put out on porches (Jack-O'-Lanterns), the Christmas lights put up, the flags hung out at an annual rate.

The maps toward the front of the atlas are about the neighborhood in its continuity with the city, with the Piedmont, with the stars: what is unchanging or changing at a glacial pace. The maps toward the back of the book are about the neighborhood in its discreteness in the city, its here and now-ness: this year's jack-o'-lanterns, the afternoon's sounds (Sound Walk, Barking Dogs), the colors of this fall's leaves (Autumn Leaves). The maps woven through the middle try to capture the broad givens of the front giving birth to the literal facts of the back, and vice versa: the churning and grinding that transforms the city into the neighborhood and the neighborhood into the city . . . on the fly.

The historical maps would go here too, for the historical transformations—from Tuscaroran fields through slave plantation to residential subdivision—catch the transformer at what we might have thought about as a geologic pace if geology itself hadn't already written its history here (Boylan Hill, Intrusions Under Hill). Six hundred million years ago what is now Boylan Heights lay at the bottom of the Iapetus Ocean.

The History of the Neighborhood Leaves Traces the Maps Catch

The rhythms we find today—or those that could be felt in the 1970s and 1980s—taken together make up the history of Boylan Heights in

a very *familiar* sense. My son Randall—he'd inherited Lester's route — delivered the last *Raleigh Times* ever to be delivered to houses in Boylan Heights on November 30, 1989. This was at a time when afternoon papers all over the country were going out of business. The *Times* had started publication in 1901, gone bankrupt in 1910, and restarted in 1912. Boylan Heights had been carved out of the old Boylan cotton plantation in 1907, though by 1912 it may not yet have had enough residents to justify a route. But for the next seventy-seven years, delivery of the *Times* was a beat in the rhythm of the neighborhood, a daily beat and, since it didn't publish a Sunday edition, a weekly one too.

It was in 1907 then that the old Boylan plantation began its transformation into Boylan Heights the neighborhood. Purchased by the Greater Raleigh Land Company (it was real estate speculation— nothing's changed) and laid out by Kelsey and Guild (a Boston-area landscape architecture practice known for its City Beautiful proclivities), the neighborhood was designed with a "sensitivity" to the shape of the land, with curved streets (Streets), a central park, buried water and sewer (Intrusions under Hill), and sidewalks. It wasn't a big subdivision, only some 300 lots. The neighborhood stretches less than a half mile in each direction.

Because the ideal, white, middle-class suburb envisioned by Kelsey and Guild was not a homogenous gated community (some things have changed) but a heterogeneous simulacrum of the city at large (at least the white city at large), restrictive covenants were incorporated into the deeds of sale that placed minimum values on construction (Shotgun, Bungalow, Mansion). The most expensive homes, to cost at least $2,500, were built on Boylan Avenue near Montfort Hall. Houses on secondary streets like Kinsey and Cutler cost as little as $2,000. Still less expensive homes were built on the streets that wrapped around the bottom of the hill (Rooflines, Stories). Need I say black ownership was forbidden? It was stipulated in the language of a typical covenant, "That the premises shall not be occupied by negroes or persons of mixed or negro blood, [but] that this shall not be construed to prevent the living upon the premises of any negro servant, who is employed for domestic purposes." Whereas the other covenants expired at the beginning of 1920, this one never did. And so: the richest whites at the top of the hill, the less wealthy arrayed around them, the poorest at the bottom toward the creek and the branch (Assessed Value), with blacks scattered among them as domestic servants, otherwise banished.

As all involved labored to bring Kelsey and Guild's vision to life, Boylan Heights grew rapidly. In 1921 my grandfather Lehman took a job with Carolina Power and Light and moved his family, including my father Jasper, from Wilmington to a little house on Florence Street, then later to a larger house a couple of blocks west on South, and finally to a third house just down the alley from where Ingrid and I would later live. On a visit in 1979 my aunt Marie Krawcheck drew a map of the Boylan Heights she remembered from the 1920s (Aunt Marie's Map, at right). Her concluding note says, "I'd walk to school down West South thru 'colored town' to Centennial School where they tell me the auditorium is now." This new auditorium was built in 1932, and my aunt walked through "colored town" because when she lived in Boylan Heights, it couldn't yet justify its own school. By 1927 though, the year General Electric moved my grandfather and his family out of Raleigh, enough young families had moved into the neighborhood to justify the construction of a school in what had been Boylan Springs Park.

The dreams of Kelsey and Guild and the Greater Raleigh Land Company had come to fruition. These were the years to be living in Boylan Heights.

They didn't last. When a new high school opened north of the neighborhood in 1929, and the school board opted to keep the Boylan Heights kids east of downtown at Hugh Morson High, it was the end

Aunt Marie's Map

1. Small bungalow that was red when we lived in it. The street wasn't even paved. Our first house.

2. Our second home—brick bungalow with steep steps—where I used to lock Jap in the closet.

3. Jap's old friend Harry Way lived here.

4. Little old country-style store where the men played checkers on the rail out front.

5. The Terrells lived here—Sara Frances and Ben, Jr. Sara Frances was Jap's girlfriend.

6. Our last home in Raleigh that was owned by the family in No. 7. They kept peacocks in a pen at No. 8 that we had almost in our backyard.

9. My girlfriend Dorothy Champion lived here with her grandmother in a big old wooden house on this pie shaped lot.

10. This is the branch where Jap always fell in and I'd bring him home soaking wet.

11. The wonderful woods where I'd pick wildflowers, especially gorgeous violets.

I'd walk to school down W.S. [West South] thru "colored town" to Centennial School where they tell me the auditorium is now.

of any éclat the neighborhood might have been able to claim. The growing white city spread past it north, then west toward what was then State College. Increasingly, the south and east were stigmatized as "colored" parts of town. Then the Depression hit and World War II and, by the time that was over, Boylan Heights was altogether the wrong place to be. The folks who came to Raleigh when IBM moved to Research Triangle Park settled in new suburbs far to the north. The state built the Beltline to speed them to work, North Hills and Crabtree Valley Malls opened, and pretty soon there was no reason for people to come downtown at all.

By 1974 when Ingrid and I moved into the neighborhood—we didn't own a car and it was within easy walking distance of both downtown and State, and we liked the old houses and the funky mix of people—the nicest thing most people could say about Boylan Heights was that it was struggling. One of the things it was struggling with were blacks. Under Jim Crow the closest blacks had been able to get to Boylan Heights was the east side of Gas House Creek. As I said, Gas House Creek ran along the bottom of the hill behind the houses on the east side of Florence. Its name came from the coal gasification plant just east and down the hill from the neighborhood and, in fact, in 1974 the old gasometer was still standing. With Jim Crow winding down, there was no longer anything to stop blacks from moving up the hill. With the division of the grand old houses into rentals—and landlords who increasingly lived outside the neighborhood (Absentee Landlords, Local Rents, Families)—there was also plenty of opportunity. The longtime white residents—racists like my grandparents—were very unhappy about this, and the Boylan Heights Garden Club, which had been founded in 1957, became a forum for discussions that, in 1974, led to the founding of the Boylan Heights Restoration and Preservation Association (Newsletter Prominence). Spearheaded by a couple of early gentrifiers, it successfully campaigned for changes in the

neighborhood's zoning that made it more difficult to convert single-family houses to rentals. Hip, young lawyers with their offices downtown found the location, and the prices, congenial. The next thing you knew—in the 1980s when we were mapping it—the place was "up-and-coming."

Since then Boylan Heights has morphed into one of the city's most desirable locations. Downtowns are back again—Raleigh's certainly is—and there was a recent moment when the mayor of Raleigh, the chairlady of the county school board, and a state assembly lady all lived within a block of each other on Boylan Avenue and McCullough Street. Once again it's substantially single-family houses and property values are way up. Ingrid and I couldn't possibly have afforded to move into the neighborhood now—a veterinarian lives in our old house these days—but it's doubtful we would have wanted to.

You know, times change.

The Transformer Stops for No One

And because they do, maps become historical documents the second they're made. This is almost preposterously true of these maps of Boylan Heights which reflect the neighborhood not only in the first flush of gentrification but also after two bridges at the north end of the neighborhood had just been knocked down, the old Warren truss on Boylan Avenue and the Martin Street Viaduct. The viaduct had never carried a lot of traffic, but the bridge had been the neighborhood's link to the north, to its schools, for example (by then Hugh Morson High had also been knocked down), and cars had flowed over it in a steady stream. With its demolition, traffic pretty much disappeared from the north end of the neighborhood (Signs for Strangers). This seeps into the maps in a variety of ways. It's there in The Night Sky in the fact that a couple of us were able to lay on our backs in the middle of Boylan Avenue at 10:00 p.m. in the early part of July and sketch the horizon and the stars.

You'd be run over if you tried that today since, compared to that of 1982, the traffic pattern has effectively rotated 90°. Today traffic flows across a new bridge—the viaduct has never been replaced—through the neighborhood north-south, while the east-west traffic that used to gush through it has been rerouted around it to the south. These days you can't drive west out of Boylan Heights at all. These changes would be reflected in corresponding changes to Signs for Strangers (and its attached map of traffic flow), Police Calls, A Sound Walk, and even to Assessed Value because property values rise when an inner city neighborhood of neat, old houses gets turned into the equivalent of a suburban cul-de-sac. All these changes have gone hand in hand with, driven and been driven by, the ongoing gentrification. They're further examples of neighborhood as process, as transformer.

The recent loss of a third bridge speaks to the limits of gentrification. This is the old Munford Avenue Bridge that used to carry traffic to Central Prison when its entrance faced north. Then you either bumped across the railroad tracks—unless there was a train—or reached it through the neighborhood: down Mountford Avenue, over the Munford Avenue Bridge (the spelling's never been consistent), and so down to the prisons (plural, because before you reached Central, you passed Triangle Correction Center). As I said, this was a minimum security prison—now long gone—with an exercise yard (weights, basketball court) right below the bridge. Families and friends of inmates used to hang out on the bridge, watching them and waving and hollering at them. When the Department of Corrections closed Triangle, the neighborhood had high hopes, maybe for a little park, maybe even (fingers crossed) the closing of Central itself. Instead Central launched a $160 million expansion on the old Triangle site. In the process they truncated Mountford Avenue at the bridge head.

As I said, times change.

And *none* of this has made it into the atlas: the transformation

```
Boylan Heights Restoration and Preservation Association

            ******** NEWSLETTER ********
For Residents of Boylan Heights    First Issue    August, 1974
```

The monthly neighborhood meeting of the Boylan Heights Restoration and Preservation Association will be held at Boylan Heights Baptist Church on Thursday, August 22, at 7:30 P.M. All property owners and residents of our community are urged to attend. Mr. Beal Bartholomew will speak on zoning and show slides of houses in our neighborhood that have been restored. There will be a suggestion box provided at the meeting for ideas, suggestions, or criticisms, signed or unsigned.

A community picnic has been scheduled at 4:00 P.M. on the Boylan Heights Church grounds on Labor Day. Further details will be announced.

We welcome all newcomers to our neighborhood. The most recent ones reported are:

Mr. and Mrs. Bob Wright, of 413 Kinsey St., who have installed a new picket fence.

Mr. and Mrs. "Chuck" Harper of 407 S. Boylan Ave.

Miss Marty Phelps, Mrs. Ellen Prevette, and Mr. and Mrs. Dennis Wood, of 402 S. Boylan Ave., the home that Mr. Ben Floyd renovated. It really gave a boost to the appearance of this street.

Mr. and Mrs. C.H. Fulghum have done extensive remodeling to their home at 1009 W. South St. His brother Bill and his wife, newcomers, are remodeling at 1005 W. South St.

Mr. and Mrs. Stoney Eastman have recently moved to 509 Cutler St.

The David Ophill family, whose home was burned at 309 Kinsey St., have begun rebuilding.

Congratulations to Mr. Stanley Medlin and his mother, 917 W. South St., who won the garden club plaque for this month. It is given for the most noticed improvement in the yard.

Congratulations to Stephanie Wells, daughter of Mrs. Helen Wells, of 411 Kinsey St., for winning a hula hoop contest sponsored by the Raleigh Parks and Recreation Department. She also won in Charlotte. If the City had had sufficient funds, she would have competed in Atlanta, Georgia.

Our best wishes to Mr. and Mrs. Glenn Bobbitt who were married on Saturday, August 3! Mrs. Bobbitt is the former Mrs. D.R. (Dorothy) Ferrell of 730 S. Boylan Ave.

Mrs. Ernest Goolsby of 1018 Dorothea Dr. is still on the sick list but is able to be at her daughter's home in Garner.

Mrs. Pauline B. Fish of 406 Kinsey St. is in Wake Memorial Hospital. We hope she is soon able to be out.

of Boylan Heights Elementary School into Project Enlightenment, the collapse of the *Raleigh Times*, the final demise of the old guard (their Garden Club's finally gone too), the demolition of Triangle Correction Center, the inauguration of the annual Art Walk, the opening of the Boylan Bridge Brewpub (which, as I write this, is celebrating its first year with a "new high gravity and super tasty Boylan Bridge Anniversary Ale"). But then none of the earlier stuff made it into the atlas either: the Indians and the slave plantation, the establishment of Raleigh (in 1792!), the laying of the rail lines, the construction of Montford Hall, the Union soldiers camping on the hill. There are *so many* maps left to make! Just to finish!

The data are endless. We went door to door in 1975 asking intrusive questions about length of residence, occupation, magazine subscriptions, radio habits (Radio Waves), and pets (Dogs), among other things. In 1982 we recorded information for each dwelling about the number of stories (Stories) and porches (Roof Lines), height from ground, porch railings, step railings, mail boxes, wind chimes (Wind Chimes), hanging plants, planters, porch swings, awnings, screens, porch lighting, porch furniture, porch grills, wood storage, other features ("incredible Corinthian columns," "concrete swans"), house foundation colors, house colors, yard grills, garages, garbage can holders, can condition, clothes lines, retaining walls, auto repair, evidence of kids, and "miscellaneous yard/porch funk" ("shed, cathouse, many irises, pie pans in trees"). I have draft maps of most of this.

The historic data exploded with the neighborhood's registration as a National Historic District. You can get the date of construction along with a description ("One-story Bungalow; gable faces street. Attached porch gable faces street off-center; wood shingles and siding") for every building in Boylan Heights . . . online! You can get very high resolution aerial imagery of the neighborhood . . . online! Using

Google's Streetview, you can look at every house . . . online! But it's all disaggregated, inchoate. Something's missing, maybe the poetry.

There is another map I want to make of the underground. You'd look up at the neighborhood from below, from underneath the trees' deepest roots, up through that latticework—that mesh!—to the mains (as in Intrusions under Hill), but then you'd look through the mains to the house connections snaking up *into* the houses and forking there into the toilets and sinks and tubs and showers like capillaries, and then out again, down the drains and through the waste pipes to the laterals and so down to the sewer lines, the house itself suspended in this web of flows, crystallizing out of them. *Can you see it?* You wouldn't see the house itself, just the water lines reaching up—as if to the sun, like branches—*almost* touching the drains. In the gap between? You, standing in the shower, the water shooting up from the underground, fountaining from the showerhead around you, cascading to the floor, pooling to the drain, and so down, down, down, you suspended in that gap, in that space, in that fountain.

Lawrence Durrell says:

> You tell yourself that it is a woman you hold in your arms, but watching the sleeper you see all her growth in time, the unerring unfolding of cells which group and dispose themselves into the beloved face which remains always and for ever mysterious And if, as biology tells us, every single cell in our body is replaced every seven years by another? At the most I hold in my arms something like a fountain of flesh, continuously playing, and in my mind a rainbow of dust.

Which is all the neighborhood is: a fountain of flesh and shingles and concrete and two-by-fours and trees and asphalt and iron pipes and starlight and the leaflight cast on the sidewalks on a summer's night.

Neighborhoods are experienced as a collection of patterns of light and sound and smells and taste and communication with others, and here, in this atlas, I've tried to catch those patterns in black and white and arrange them so that the larger pattern, the pattern of the neighborhood itself, can emerge by flipping through the pages.

Maps for a narrative atlas . . .

There is a temptation to update the atlas, to change the traffic map to chart today's pattern, the assessed value map to display the new affluence, the jack-o'-lantern map to include all the gentrifiers carving pumpkins these days in the parts of the neighborhood where in the early 1980s nobody bothered. If the atlas were a reference volume and people relied on it to choose their route to a movie theater, there might be some reason to consider this. But it's not a reference atlas and never was and there's as little reason to update its maps as there is to update Balzac's Paris to include the Grande Arche or the demolition of Les Halles whose loudly lamented buildings were, in any case, constructed after Balzac's death. The transformer stops transforming for no one, every glimpse is fleeting.

Only cartography's general reference map pretends otherwise, has the hubris to present the world, you know . . . *as it really is*, as if to say Europe, not the topography of Europe at the end of the last ice age or the population of Europe during the High Middle Ages or the state system of Europe today, but Europe, the real deal, *now and forever.*

I say to you there is no real deal. There is only this starlight falling tonight on these asphalt streets still warm with the sun's heat, these slopes down which the streets slip, these mains beneath them with the runoff from this afternoon's rain, and—listen!—if you bend over

the manhole cover, you can hear the sound of the rushing water. There are only these wires scarring this sky, these trees with their heavy shade, this streetlight casting those shadows of branch and leaf on the sidewalk, those passing cars and that sound of a wind chime. But none of it is Boylan Heights *tout court* and none of our maps pretends to catch more than a note or two of a world in which everything's singing.

Bibliographic Note: Octavo has published all there is of Mercator's *Atlas sive cosmographicæ meditationes de fabrica mundi et fabricati figura* on a pair of CDs. It comes with an English translation and commentary by Bob Karrow. The Blake quatrain comes from his "Auguries of Innocence." Thoreau's knot-hole is in his journal entry for January 16, 1838. Barthes made his remarks about consecution and consequence in "Introduction to the Structural Analysis of Narratives," in his *Image–Music–Text*, page 94. Duchamp's description of making his *3 Stoppages Etalon* can be found in the Jennifer Gough-Cooper and Jacques Caumont *Ephemerides* at May 19, 1914. Domínguez first described decalcomania "with no preconceived object" in 1936 in *Minotaure 8*. Cage quoted Brown often, but you can find it on page 135 of Cage's *A Year from Monday*. Cage's remark about humanity and nature not being separate comes from *Silence*, page 8. Tommy Stubbins opens an atlas blindfolded in the "Blind Travel" chapter of Hugh Lofting's *The Voyages of Dr. Doolittle*. Hans Arp describes his intentions as a Dada in *Unsern täglichen Traum* (Zurich 1955), here in a translation by Rudolf Kuenzli. Kidron and Segal published their first *The State of the World Atlas* in 1982. (Published in the U.S. for years by Simon and Schuster, they're now edited by Dan Smith for Penguin.) Bunge published *The Nuclear War Atlas* in 1982 as a two-sided poster that he took door to door. Blackwell brought it out as a book in 1988. McEvedy, professionally a psychiatrist, published his first atlas, *The Penguin Atlas of Medieval History*, in 1961. (John Woodcock drew the exemplary maps.) You can read about Neurath's Isotype in Marie Neurath and Robin Kinross's *The Transformer: Principles of Making Isotype Charts*. Bayer's atlas was published in 1953 by the Container Corporation of America. The whole atlas is online. Pound's poem, "In a Station of the Metro," came out in *Poetry* in 1913. Williams published "The Red Wheelbarrow" in 1923 as "XXII" in his collection *Spring and All*. Kenneth Patchen's "The Orange Bears" comes from his *Red Wine and Yellow Hair*, 1949. He reads it on a Smithsonian Folkways CD, *Selected Poems of Kenneth Patchen*, that Folkways originally released in 1959. Durrell's description of a fountain of flesh comes from *Clea*, p. 98 in the Dutton edition.

THE NIGHT SKY

This is what you see at night, in early July, if you're in Boylan Heights and you look up at the sky . . . *if* you can get out from under the trees. At the top of the hill, in the middle of Boylan Avenue, we lay on our backs to make this map of the stars above the neighborhood.

It was about ten o'clock and the asphalt was still warm with the day's heat. We had a star finder, a flashlight to read it with, paper and pencil. We made a sketch of the horizon and roughed in the stars we could see and returned the next day to make dozens of detailed drawings. Afterwards we linked these together for a 360° view and used charts to make sure of our stars. With a shrunk-down copy, we went back to the street at night and fiddled with it until we got it right.

During summer in Boylan Heights, when you look up, you mostly see trees. At the right, where the horizon dips toward the north, you can see across the cement factory toward downtown and the cylindrical bulk of what was then the Holiday Inn. The white rectangles at top are the lit windows of a house on the east side of Boylan Avenue. The streetlight's on the west side. The mass of foliage to the left leads south down Boylan.

Above? Vega—one of the night sky's brightest stars—is nearly overhead in the Lyre of Orpheus that the Muses placed in the sky after he died. Zeus put the Ursas in the sky. With the glare and summer humidity, we couldn't see Ursa Minor at all, and all we could see of Ursa Major was its tail, our Big Dipper.

Where is Boylan Heights? It's in the United States and North Carolina and Wake County and Raleigh, but first and last it's in the universe. As William Saroyan said, "Birth is into the world, not into a town."

NESTING

As branches support and protect birds' nests, so city, county, state, other political bodies and services support and protect neighborhoods. Here Boylan Heights, in gray, is seen nested within, smallest to largest, a couple of service routes (newspaper, mail), city service districts (police, fire, garbage, planning), a state election district, and Wake County school attendance zones. The largest shown here—Washington Sixth Grade, Daniels Middle, and Broughton School Attendance Areas—run right off the map.

Still, these are nested within even more encompassing entities: the City of Raleigh, Wake County Soil and Water Conservation Districts, Wake County, the Capital Area Metropolitan Planning Organization, the 4th U.S. Congressional District; and larger than even those, North Carolina, the United States, NATO, the United Nations.

You participate in the affairs of the universe because you're human. You participate in these entities because you live in Boylan Heights.

	
............	Washington Sixth Grade Attendance Area
— — —	Broughton High School Attendance Area
- - - - -	Daniels Middle School Attendance Area
- - - - - -	Central Planning District
............	Wiley Elementary Attendance Area
————	Fire District 1, Company 13, Second Alarm
————	Voter Registration District D24
- - - - - - -	Fire District 1, Company 13, First Alarm
............	Garbage Route 1134B
————	Central CAC
————	Police
————	Gas
————	Newspaper
————	Mail
————	Historic District Proposal

BOYLAN'S HILL

Boylan's Hill wasn't always a hill. It was once a southern spur of the east-west ridge that runs from the state capitol to the fairgrounds. Pigeon House Branch cut the north side of the ridge. Rocky Branch still claws away at the south side, and two of its tributaries shape the spur: Gas House Creek on the east side and, on the west side, an unnamed and now almost wholly culverted watercourse that flows under the prison. Rocky Branch continues east, to join Crabtree Creek which flows into the Neuse River which flows into the Atlantic Ocean. Whenever it rains, it takes a little bit of the spur with it.

But the hill itself is distinctly man-made. In 1848 William Boylan—newspaper man, land speculator, and owner of numerous plantations—convinced the North Carolina Railroad to lay in its line across the Wakefield plantation land he bought thirty years earlier, turning a tidy profit. The tracks required a cut through the spur, thus severing the ridge and making Boylan's Hill.

Boylan didn't leave much of his fortune to William Montford Boylan, his hard-drinking, fox-hunting son, but in 1855 he did give him the hill. In 1858 the son crowned it with Montfort Hall, an Italianate mansion designed by the English architect William Percival. While it's only 349 feet above sea level, it's still downhill in every direction. And in *every way*. Fifty years later, when Kelsey and Guild laid out the neighborhood, they used the topography to set the social gradient: every strata of class from the mansion at the pinnacle down to the shotgun houses near the creek beds.

Scale
1 inch = 380 feet

INTRUSIONS UNDER HILL

At the base of the hill, where Rocky Branch is still wearing it down, you can run your fingers along the veins of intruded quartz and imagine it was once molten and mobile. Hundreds of millions of years ago, sedimentary and volcanic rocks accumulated under the neighborhood and metamorphosed into a mix of mica, hornblende schists, and gneisses. Over millions of years, this mass has repeatedly uplifted and eroded. The hill continues to change.

You can also see the city as a geologic agent: it too cuts into the hill, laying intruded arteries (water mains and gas lines) and veins (the sewage pipes). Together they tie the neighborhood *into* the city, then *through* the city to the Neuse River where the city dumps its heavily treated sewage and further to the gas fields of east Texas.

water

gas

sewer

intruded steel

intruded quartz

SQUIRREL HIGHWAYS

Just as pipes vein the underground, overhead lines innervate the neighborhood, electricity and information flowing out of and back into national and international grids.

Each powerpole has a birthmark, a metal tag that says who owns it—mostly Carolina Power & Light. The other utilities rent space. When all the utility lines are attached to a single pole, they stack up like this: naked electrical lines on top, copper phone lines (bundled in black, shielded cable) next, then the cablevision lines, fat, shiny, and silver.

Nervous squirrels, afraid of an attack on the ground, use the phone and television cables as highways wherever the tree canopy's broken. Birds rest on the power lines. "Man and nature, not separate"

```
              1
         4-5  |  2-3
           \ | /
            \|/
             *————— 8+
            /|
           / |
         6-7 ■
             •   suspended intersection of lines
         power pole
```

TREES IN GENERAL

Bridging overhead and underworld, any tree could be the *axis mundi* around which the universe turns. From spring's leafing to winter's naked limbs, theirs is the essential rhythm of the neighborhood, its truest clock. Yet, their pollen is a yellow scourge; the autumn leaves clog the gutters; black walnuts and pecans dent the roofs of cars. In winter, rime-coated limbs break and short out power lines. In hurricanes, whole trees smash through houses.

Shaub Dunkley named and counted 1171 individual trees and twenty-four tree clusters in Boylan Heights, not all the trees but enough to get the picture. He completely mapped eight blocks mostly in the northwest—every tree, sapling, and stump. The reliability diagram at right shows how he mapped the other sixteen blocks in the neighborhood. In this way, the maps are of spotty intelligence, like our maps of Inner Asia or the Amazon or any unknown territory . . . like a nearby neighborhood.

Reliability Diagram: Boylan Heights

- only street trees surveyed
- street trees and large trees in block interiors surveyed
- all trees surveyed

Trees in General
map at right

- tree or cluster of trees

BROKEN CANOPY

Downtown Raleigh "Forest"
(Area represented is two miles across)

Three hundred years ago, this was a great, dense deciduous forest. Now the tree canopy is broken almost everywhere, and in some places—heavily institutionalized ones—there are virtually no trees at all.

Where the map is blank, less than 20% of the surface bears any vegetation. Elsewere on the map, the herb coverage averages around 50%. When the photo used to make the map was taken in the 1970s, there were still foxes, beavers, and deer (long gone were the bears, mountain lions, badgers, and wolves). Within a mile of Boylan Heights, these days only the deer survive. Beyond this urban core—and the map—where residential densities drop, true forest habitat reemerges and the canopy approaches closure.

Boylan Heights is hardly a forest, but it is a little island of tattered green between the tree wastelands of Central Prison and downtown Raleigh. Only solitary trees and shreds of tiny groves tie the neighborhood into what's left of this urban woodland.

Types of Trees
map at right

. coniferous trees
o deciduous trees

AERIAL VIEW

This is what Boylan Heights looked like.

Central Prison is in the upper left corner, and Triangle Correction Center is in the upper right of the prison site next to the Norfolk & Southern tracks. Cabarrus Street runs straight east-west across the neighborhood. Toward the east, there's a circular structure, the gasometer built for the old coal gasification plant. The street running south of the gasometer is South Saunders. To its east, in the lower right, is Heritage Park, a public housing project. Everything west of South Saunders and south of Boylan Heights is Dorothea Dix. Rocky Branch runs beneath the dark band of trees lining the northern edge of Dorothea Dix.

The lazy S is Boylan Avenue. Just to its left, Montfort Hall is circled. At its intersection with Cabarrus is the old elementary school. To the east of the schoolyard, Florence Street runs north-south. If you look carefully at the eastern edge of the backyards on Florence, you can see Gas House Creek. Rosengarten Place, just east of the creek, wasn't paved yet. It was the western edge of the "colored town" my aunt Marie walked through to get to school in the 1920s.

If you didn't see any of this, that's what the maps are for. Flip to page 55. There's a map of neighborhood streets—abstracted, classified (surfaced and unsurfaced), named—but nothing else.

DISFIGURED TREES

In the aerial photo, you can see the trees but not their condition. The Asplundh Tree Experts, with their "cost-effective line clearance services," came through the neighborhood, under contract to Carolina Power & Light, to clear branches near power lines. You think it's *your* neighborhood, that the tree shading your yard belongs to *you*. It doesn't. Not if it's in the right-of-way.

Here is a map of trees entangled with the lines. Some near the lines suffered only a side trim. Those directly below the lines could be butchered, just like the pin oak, seen here, that once shaded *our* yard at 435 Cutler. It shaded us from both the sun and the street lights. On summer nights, the leaves shuffled in the breeze, softening the harsh glare of the street lights and casting shifting shadows.

○ full growth but side trimmed
● under utility lines

POOLS OF LIGHT

When, in the later 19th century, Americans began systematically to light their streets, it was seen as a wholesome influence to cleanliness, as a deterrent to throwing garbage into the streets under the cover of darkness, and as an inducement to leaving windows open at night for healthier sleep. People felt safer in the less dark night. Vandalism and street crime declined. It was no longer necessary to travel solely on moonlit nights.

STREETS

The street plan is like an Annunciation, not Gabriel to Mary, but Boylan Heights to Raleigh: "Rejoice, for the eighteenth century is over!"

In 1792, in the waning days of the Enlightenment, William Christmas drew Raleigh's original plan as a gridded square, a mile on a side, the neoclassic vision of an urban capital. A hundred and fifteen years later, Kelsey and Guild, under the waxing influence of Frederick Law Olmsted, laid out Boylan Heights as a Romantic residential garden, its curvilinear streets endowing the subdivision with a suitably "natural" form.

They had a pretty clean slate. William Montfort Boylan had kept the growing city at bay: the city streets stopped dead at his property. When Kelsey and Guild platted Boylan Heights, there was only the mansion, the remnants of its orchard and kitchen garden, and the reverting fields of the former plantation.

Kelsey and Guild first connected the new neighborhood to the city by extending existing parallel streets from the 1792 plan—Cabarrus, Lenoir, and South Streets—but curving them so that they crossed. Nine of the new streets were named after William Montford Boylan's family: Mountford and Boylan after Boylan himself; Stokes and McCullough after Boylan's mother, Elizabeth Stokes McCullough; Kinsey after Boylan's wife, Mary Kinsey Boylan; and Florence after a daughter, Florence Boylan Tucker.

There were few cars in 1907. Instead, Kelsey and Guild thought about pedestrians, street cars, and maybe a horse. This explains the absence of driveways (alley access is another reason) and garages. It also explains why, now in the 21st century, Boylan Heights has a surprisingly urban feel: most everyone parks on the street.

■ surfaced
▨ unsurfaced

FOOTPRINTS

Giambattista Nolli perfected the idea of the ichnographic city plan in his 1748 map of Rome.

Ours makes plain how sharply Boylan Heights (center) distinguishes itself not only from downtown (above right), but from the monolithic enclaves of Central Prison (left), Dorothea Dix Hospital (below left), and even West Raleigh with its many apartment buildings (above).

It also makes plain how much open space there is.

SIGNS FOR STRANGERS

If there were no strangers moving through the neighborhood, there would be a kind of silence: no signs. On this map, many local streets wholly vanish. Others are merely hinted at by stop signs.

Where strangers travel through the neighborhood, where the streets are *city* streets, there are a lot of signs with a lot to say. The streets Kelsey and Guild extended to connect the neighborhood to the city were seized by city planners. They yoked Lenoir Street and Cabarrus streets into a one-way pair with Dorothea Drive and South Street to move traffic between the growing suburb of Cary to the west and downtown Raleigh to the east. Eliot said, "I do not know much about gods; but I think that the river is a strong brown god—sullen, untamed, intractable," and so was the traffic that poured east through the neighborhood in the morning, west in the afternoon.

The signs are informative, but at the same time they bespeak a politics of control. The city demonstrates its authority, limns the limits of neighborhood autonomy by directing a river of steel through it. The only signs the neighborhood itself put up were two decorative wooden ones that simply say, "Boylan Heights."

POLICE CALLS

The intersections where strangers were passing through are easily located by the overwhelming number of traffic accidents (despite the abundant street signs). While the streets that were invisible on Signs for Strangers no longer are.

Seemingly quiet Cutler Street—with its sporadic stop signs—runs here as a river of crime, with the notorious rooming house at 410 sticking out like a carbuncle. At the top of Cutler, the repeated calls to talk with an officer were made by just one woman, Thelma. All over Boylan Heights, numerous calls to report disturbances reveal a general reluctance to knock on neighbors' doors and ask them to "turn it down."

Boylan Heights is small and hardly crime-ridden, but this is only a six-month harvest of calls to 911.

Call Types (by number)

1	general	14	disturbance	27	robbery
2	talk with officer	15	traffic	28	motor vehicle theft
3	stray dog	16	vehicle blocking passage	29	shooting
4	barking dog	17	motor vehicle accident	30	assault
5	pick up animal	18	request services	31	prowler
6	other animal	19	assist persons	32	fight
7	animal injury	20	injured person	33	drugs
8	animal bite	21	man down	34	forgery
9	investigate person	22	ambulance and EMS	35	rape
10	investigate vehicle	23	public drunk	36	missing persons
11	open door	24	property damage	37	attempted suicide
12	security check	25	larceny	38	fire
13	burglar alarm	26	burglary		

Call Frequency (by size)

8 one call 13 seven calls 16 fourteen calls

NUMBERS

When we made our map of Police Calls, dialing 911 got you an operator. You had to tell her—they were still mostly women then—where you were: you needed to know the address. Today this is done "automatically" as the Incumbent Local Exchange Carrier (your local phone company) is tied into the Automatic Location Information database (that your local government maintains). The technology for locating a cell phone is different, but the cops still need an address.

It's hard to imagine a time without house numbers, but they were only invented in the 16th century. They remained uncommon until the 18th and 19th centuries when postal service began to catch on (and literacy and all that implies), and commercial interests began to realize how much city directories (inconceivable without house numbers) could help their businesses. Their ever-growing personal utility—to invite acquaintances to a party, to inform strangers where to return your straying dog—makes it hard to believe that house numbers really emerged to give all levels of the modern state (see Nesting) access to each and every household: to tax, to draft (or register), to evict (if you're behind in your rent or the bank's foreclosed on the property).

Raleigh uses the "block system" to number itself: addresses rise by 100 at every cross street; and when Kelsey and Guild dragged Cabarrus, Lenoir, and South Streets into the neighborhood, they dragged this numbering system with them. Because addresses combine a house number with a street name, numbers can be reused. There's a 1003 Cabarrus, a 1003 Lenoir, a 1003 South, and a 1003 Dorothea Drive.

Your address becomes part of your identity: giving your address after your name is all but automatic. It's on hundreds of records, all now digitized. If you own your house, punching your address alone into a browser will cough up your name, your mailing address (if different), a photo of your house, its size, number of rooms (heated and unheated), number of baths, its age, its resale value, its tax value, dates of improvements (often with value), last sale price (often a long history of sale prices), nearby schools (with distances and ratings), property taxes paid, and so much more. And that's just the tip of the free public record.

You know the marketers who mail to "… or Current Resident"? This is the Boylan Heights that exists for them. The numbers are all they know, all they can "see."

MAILMAN

 Like commuters Tommy Rogers drives through the neighborhood. But since he's the mailman, he stops at every house number. Letters in, letters out, bills in, checks out. Tommy is a medium, and though he seems to belong to the neighborhood, he never stays.

 Everybody knows his route. You know where he's been and where he's going. While people brace themselves for the rush hour traffic that pours through the neighborhood, they eagerly await Tommy's arrival: "Has the mail come yet?" It sets up a daily rhythm—and a weekly one when he's not there on Sundays.

LESTER'S PAPER ROUTE IN SPACE & TIME

Every afternoon Lester Mims got on his bike and delivered the *Raleigh Times,* setting up another rhythm for the neighborhood ("Has the paper come yet?"). Unlike the morning *News and Observer,* which had a strong national and statewide orientation, the *Times* was the local paper. If Boylan Heights made the news, this is where it made it.

Unlike the map of the mailman's route, this map shows you not only where Lester went but how long it took him. We made the temporal dimension of Lester's route explicit with a space-time ribbon. Space is caught here by the neighborhood streets, seen obliquely from the southeast, at bottom. Lester's route unfolds above the streets, following their outline, rising along the temporal dimension which runs *up* the page.

The ribbon touches the neighborhood at Lester's house on Cutler Street where he began. From there, you can drop a line vertically from each inflection of the ribbon to a point on the map. The first segment shows Lester heading north on Cutler, the next his turn at the first intersection to head west down McCullough. The third segment ends where he turned south onto Lenoir. And so on. Each segment represents one minute: the longer a segment, the greater the distance Lester covered. Shorter segments cover less ground per minute, meaning more papers to throw. Longer segments mean he biked faster because he had fewer customers.

It took Lester twenty-seven minutes the day we timed his route.

TWO ROUTES

Scott was the manager of the *Raleigh Times* District 170. He recruited, supervised, and collected from the carriers, as well as delivered bundles of papers to them. For Scott the neighborhood was one stop on a long route through the city. Each afternoon he spent barely three and a half minutes in Boylan Heights.

We've added a ribbon for Scott's route, and because he moved much more rapidly than Lester, each segment on his route represents only thirty seconds. The segments on Lester's route are still equivalent to a minute, but we've also used a different temporal metric for Lester here, compressing it relative both to the previous version of his route and to Scott's. When we timed Lester for this diagram, it took him just twenty-six minutes.

THE PAPER'S ROUTE

 Here we follow the Monday *Raleigh Times* through the neighborhood. It entered the neighborhood bundled in Scott's truck, was spread throughout Boylan Heights by Lester on his bicycle, then was reaggregated on Tuesday by City of Raleigh garbage truck No. 1135 which trundled it off to the county landfill. The dotted line tracks the route of a single copy, digested (as something other than cellulose) by the Poole family members at 1022 Dorothea Drive.
 The neighborhood: a metabolic machine (it eats newspapers).

DAY ONE

LESTER'S ROUTE

Lester delivers a paper to the Poole house, 1022 Dorothea Drive

SCOTT'S ROUTE

• one paper

DAY TWO

GARBAGE TRUCK'S TUESDAY ROUTE

Garbage truck reenters Boylan Heights

Garbage truck enters Boylan Heights then leaves a few blocks later

ALLEY WAYS

Here the neighborhood is turned inside out to reveal the intestinal system of alleys where people kept their trash cans and the garbage trucks hauled the trash away. That's where you saw the garbage trucks, in the alleys, unless you saw them in the intersections with the streets (indicated here by the big circles).

Every spring, at the request of Raleigh's garden clubs, the city sent a pink garbage truck around to collect the oversized trash it refused to pick up the rest of the year: refrigerators, water heaters, old sofas. Martha Maynard, the Boylan Heights Garden Club's point lady, served as the annual trash mascot, riding with the garbagemen up and down the alleys.

BUS BALLET

In the afternoon between 3:00 and 3:30, six buses twine together through the neighborhood: the prison bus, four school buses, and the city transit bus, dancing.

The prison bus carts inmates from Triangle Correction Center to second shift jobs elsewhere in the city. Its route is darkened on the map at left as well as floated above it to start the *pas du six* at three o'clock. Just minutes later, the bus from Daniels Middle School just slides in—suddenly there are kids on the streets—and then out again. Next the Capitol Area Transit bus loops through the neighborhood on its larger loop in and out of downtown. It usually idles for a while at the top of Cutler (which is what the longer dotted line describes in the diagram furthest right).

There are two buses from Wiley Elementary. The first, the 104, zigzags through Boylan Heights then leaves it to loop up Dix Hill. It returns eleven minutes later for a final lap, drawing parents out to the street to wait for their kids. The Washington Sixth Grade Center bus follows the Wiley 104 up Dix Hill, a minute behind it, but it doesn't return. Finally, there's the Wiley 118, another complicated little route that dips outside the neighborhood for just a minute. By 3:33 p.m. the neighborhood has changed: the children are home, and the air is spiced with their high voices.

Furthest right, the final four routes as free-floating space-time ribbons: a view of a neighborhood.

RHYTHM OF THE SUN

 Neighborhood rhythms: the rush hour tides of traffic, the mailman's daily rounds, Lester on his bicycle, Scott in his truck, the bus routes, and the bi-weekly garbage pickup. More: the milkman in the morning, the kids walking to Wiley and then home (*anxiously* awaited), delivery trucks for the Cutler Street Grocery, the van dropping off the residents of the Christian Fellowship Home on Cutler, the *N&O* carrier's route, folks going to and returning from work, the trains (of course!) rattling around the periphery, the Miami-bound Greyhound leaving town via Cabarrus that the kids liked to wave at. All driven by the rhythm of the sun.

 I had an insolometer on my roof. It's a device that measures the amount of sunlight that falls on it: the more sunlight, the higher the trace of the pen. The graph, then, charts the rising and setting of the sun across a few weeks in the mid-summer of 1982. Cloudless mornings are marked by a sharp rapid rise that settles into a smooth curve toward solar noon. Cloudless afternoons would mirror this, but there aren't a lot of those in Raleigh in the summertime. It's humid here. Fleets of cumulus are always sailing across the afternoon sky.

Row 1 (July):
- Sunday 18th July
- Monday 19th
- Tuesday 20th
- 21st Wednesday
- 22nd Thursday
- 23rd Friday
- 24th Saturday
- 25th Sunday
- Monday 26th (11:30 p.m.)

Row 2:
- Monday 26 July
- Tuesday 27 July
- Wednesday 28 July — *it cleared just in time*
- Thursday 29 July
- Friday 30 July
- Saturday 31 July
- Sunday 1 August
- Monday 2 August

Row 3:
- Tuesday 3 August
- Wednesday 4 August
- Thursday 5 August
- Friday 6 August
- Saturday 7 August
- Sunday 8 August
- Monday 9 August
- Tuesday 10 August

THE LIGHT AT NIGHT ON CUTLER STREET

It's very quiet in Boylan Heights at night. At midnight the streets are empty, but it's not actually that dark. There are street lights and the spill from the prison (where it's like daytime), and some porch lights burn for a late home-coming. If the cloud cover's low, there's reflected light from the city.

On a single block of Cutler, we took 151 light meter readings: a third in the street, a third on the sidewalk, and the last third—carefully, so as not to alarm the residents—at the faces of houses and in the spaces between them. It would've been good to get into the backyards, but we didn't dare.

With raw meter readings recorded on a map, we interpolated the contour lines you see here. Black stands for meter readings of 1 or less, white for readings of 7 or higher. (Had we ventured into backyards, much of the black would be lightly mottled.) The smear at the top is the end of the block at Montford, the blob at the bottom spreads along McCullough. Straight lines are house facades, and the small rings are porch lights. The brightest spots are associated with street lights though they're not necessarily located directly below them. In Pools of Light, the lamp posts are at the center of the white circles; whereas, here we're measuring the *light itself* which the foliage modulates in complicated ways. If we could've entered the houses, the dark would not be so uniform and all-encompassing: it would be speckled—at least until everyone had gone to bed.

Light Meter Readings

≤1 2 3 4 5 6 7≤

ABSENTEE LANDLORDS

An explosion of rent, an exodus of money out of Boylan Heights. By the early 1980s, half of Boylan Heights was owned by absentee landlords who lived as far away as Forth Worth, Texas, and Duluth, Minnesota, and half of the neighborhood paid them rent. The length of the line shows the distance the rent traveled out of the neighborhood, the thickness the number of properties owned. The largest explosion shows the rent flowing elsewhere in Raleigh (the thickest lines to unquestionable slumlords). The insets show its flight across the state and nation.

The threat to the neighborhood's homogeneity due to absentee landlords fueled the 1974 establishment of the Boylan Heights Restoration and Preservation Association. Desiring a neighborhood of white, single-family homes, they pushed for zoning changes. By the time the desired increase in single-family ownership was achieved, many of those most motivated had died or moved away. By then their kind of homogeneity had taken second place as a desideratum to middle-class respectability regardless of race (though even today, Boylan Heights is not diverse). Boylan Heights: process-thing unfolding in space and time.

North Raleigh

West Raleigh

LOCAL RENTS

Some rent money stayed in the neighborhood because some landlords lived there, often next door to their tenants. Resident property owners here appear as empty hexagons. Those with shapes attached to them were also landlords, and their other properties have the same attachment but with a filled-in hexagon.

One of Alma Kirk's properties was the Cutler Street Grocery Store which she ran with her son Taft. *That's* a local business.

Resident Owners

- Laura Chappell
- Sherrill Edwards
- Ernestine High
- Joseph Huberman
- Alma Kirk
- Charles Meeker
- Anne Partin
- Frank & Josephine Presnell
- Gaylon & Helvere Raynor

FAMILIES

In Kelsey and Guild's vision of the ideal, white, middle-class suburb there were only single-family homes. As their 1907 neighborhood plan filled in, some exceptions appeared: a few two-family houses and five four-unit apartment buildings. Still, as the 1950s dawned, Boylan Heights was essentially a neighborhood of single family homes.

Nothing about Boylan Heights remained fashionable by then and the neighborhood had settled into a complacent, middle- and lower-middle-class respectability, white (it goes without saying in those Jim Crow years), and middle-aged. The residents worked downtown as clerks in the government offices, as tellers in the banks, as floorwalkers in the department stores; or up on Dix Hill as clerks or nurses in the mental hospital. A few had jobs with the railroad. The more marginal lived in the often tiny houses at the bottom of the hill, the more respectable higher up in the grander ones, and it was these—too large for modern, post-war families—that attracted the attention of landlords as older residents aged out or died off. The 3,100 square footer at Cutler and Cabarrus yielded five apartments, the 2,600er at 311 Cutler seven rooms, the 2,400er at 602 South Boylan five.

Renters are not homeowners, and many of the new residents had blue-collar jobs or no jobs at all and, with the passing of Jim Crow, some were even black. They were not welcome. As the wife of a janitor told us in 1975, "Nobody won't have nothing to do with me 'cause I'm black." This was how absentee landlords diluted the homogeneity of Boylan Heights.

On the map here, except for the few two-family houses and the four-unit apartment buildings, all the numbers higher than 2 are single-family houses that had been broken up by 1974 (when the City of Raleigh collected these data). The 5's and the 7's had been broken up into rooming houses, the G's into group homes. These four group homes, while not as troubling as the blacks to the older residents, worried them nonetheless. There were two "Rehabilitation Homes," the Christian Fellowship Home (in fact a halfway house for alcoholic/drug dependent adult men, often house painters), and the Full Gospel Student Fellowship (good Christian boys).

The map's sole C, once William Montfort Boylan's home, was a whole other story. In 1952 a bunch of neighbors had converted the mansion into the Boylan Heights Baptist Church. Beginning with sixty-five members, it had grown to 213 by the time these data were collected. No one seemed to mind this conversion: it was the invariable site of the neighborhood's Memorial and Labor Day picnics.

Actually, the map understates things. In many of the 1's a room upstairs was let to a nice girl from Meredith College or an engineering student at State. Who couldn't use the extra income? This doesn't apply to the 1's at the bottom of the hill. They rarely had an upstairs, much less a rentable room.

Here's a measure of the neighborhood's gentrification, that is, a measure of its return to the social structure Kelsey and Guild originally imagined for it: in 1974 there were only 149 single-family homes in Boylan Heights. Today there are 205.

This is a good thing unless you're looking for a room to rent.

ASSESSED VALUE

The system of property values defined by Kelsey and Guild in 1907 (and written into restrictive covenants in the deeds of sale) was virtually undisturbed in 1981. According to the Wake County assessment, the highest value properties still lay along the Boylan Avenue spine and remained concentrated at the top of hill, while the lowest values were at the bottom. The $24,000 contour embraces the Boylan spine, the $17,000 contour draws in Cutler, Kinsey, and lower Boylan. The $10,000 contour includes most of the rest of the neighborhood, but values drop rapidly toward its edges. Only one property stands out as an (instructive) exception—the rental unit at the southeast corner of Cutler and Cabarrus, which was far and away the most valuable place in the neighborhood at $46,000.

Except at the edges, these houses were all large houses: 2000-4000 square feet, high ceilings, multiple fireplaces, pocket doors. The early builders often met the covenant requirements through quality materials and treatment rather than size. Though the houses do shrink as you slip downhill, it's the pillars, pilasters, and pediments that quickly disappear. In 1974, $26,000 bought us 2600 square feet, nine-foot ceilings, hardwood floors, elaborate woodwork, two fireplaces, and a large yard with two *glorious* pecan trees. Today property values are ten to twenty times what they were in 1981. The greatest relative increases have been along the edges where property has been historically undervalued, yet even in the debased, post-bubble economy of 2010, the $695,000 asking-price for a house directly across the street from Montford Hall remains two to three times that of the priciest places on the periphery.

I made the map by smoothing the assessed value of 333 residential lots across a 281-cell grid, interpolating contours across that. I glued strings to the contour lines for the rubbing reproduced here.

NEWSLETTER PROMINENCE

In August 1974, out of the ferment from which arose the Boylan Heights Restoration and Preservation Association, the neighborhood acquired a newsletter. Folksy and attentive to the arrival of newcomers, winners of contests, and the health of residents, it had an agenda: foster home improvement, foment interest in neighborhood down-zoning, and ultimately increase property values. Just as the popular kids appear most frequently in high school yearbooks, those most active in neighborhood "restoration" were most frequently mentioned in the newsletter. The newsletter is a record of social structure: its contents begged to be mapped.

I recorded every reference to an address or, absent an address, the address of anyone mentioned in the first ninety-six newsletters (1974-1982). The addresses referred to most often were on Boylan Avenue, at the top of the hill, where four addresses alone account for a fifth of all mentions. Frequently mentioned addresses were most likely to concern themselves with neighborhood business (hence the darker circle), no matter who lived there. During these eight years, three very different people lived at 324 S. Boylan. This address, the one most frequently referred to, held its rank independent of the occupants. In other words, it was the house, the address, the location that chose the movers and shakers, not the other way around.

Kelsey and Guild knew their stuff. Their 1907 plan didn't just determine property values, it fixed the social hierarchy. In 2010 the mayor of Raleigh and his wife, a member of the Wake County School Board, lived at 324 S. Boylan. The Representative for North Carolina House District 3 lived just a few doors down. In this case: still the same old map.

Mentions in the Newsletter

60+
30-59
15-29
7-14
4-6
1-3

The LIGHTER the color, the more personal the nature of the reference.

The DARKER the color, the more the reference pertained to neighborhood business.

JACK-O'-LANTERNS

I rode through the neighborhood on my bicycle—it was 1982—and took pictures of all the jack-o'-lanterns. On the map, there's a jack-o'-lantern at every address where there was one or more pumpkins on the porch, and most of those porches were at addresses that were frequently mentioned in the newsletter.

PUBLIC & PRIVATE TREES

At its highest point, the hill tumbles suddenly to the railroad tracks. This slope is a shadowed space, overlooked by the normative eye and thus by normative maintenance. No one takes care of the slope, and left alone such spaces rapidly revert to a uniquely scraggly and urban woodland: quick-growing ailanthus, privet, blackberries, honeysuckle, plastic bags.

Manicured trees stand in the little parks at the two entrances to the neighborhood, one at the top of the hill, the other on Western. These are in the city's purview as are the street trees that the city "maintains" in the utilities' interests (see Disfigured Trees). Except for the county-maintained trees in the school yard, all the other trees are private responsibilities, by and large lightly shouldered. Most people seem to feel that the trees are on their own, as if, in a way, the trees were more neighbors than property—though when the trees get out of line, you can can give *them* a good whack.

ONLY PUBLIC TREES

ONLY PRIVATE TREES

+ trees in shadowed spaces

● city park trees

✕ street trees

⬢ trees in fence rows

◻ trees in front yards

◆ trees in side yards

▲ trees in back yards

FENCES

 This is an open, welcoming neighborhood with few front yards fenced. Here, as elsewhere, the mansion sets itself apart.

———	2'- 4' wire
▬▬▬	5'- 8' wire
△△△△	2'- 4' picket
▲▲▲▲	5'- 8' picket
✗✗✗✗✗✗	2'- 4' chain link
✗✗✗✗✗	5'- 8' chain link
▯▯▯▯	2'- 4' masonry
▮▮▮▮	5'- 8' masonry
∘ ∘ ∘ ∘	2'- 4' pipes with string
• • • •	5'- 8' pipes with string
～～～	2'- 4' hedges
▰▰▰	5'- 8' hedges
┼┼┼┼┼	2'- 4' wood
╋╋╋╋╋	5'- 8' wood
◯◯◯	2'- 4' wrought iron
⬭⬭⬭	5'- 8' wrought iron

ROOF LINES

As welcoming as the open yards are the porches.

On top of the hill, a deep porch often runs the full width of each house, attached to and sometimes wrapping around it, invariably sheltered beneath an independent roof that extends from the hip-roofed house (X on the map).

The houses lower on the hill more often seem to embrace the porch: it snuggles, parallel to the street, under the long side of the house's single gable roof (—). Some of these houses are classic bungalows but most are better thought of as "bungalized."

Still further down the hill, so-called "shotgun" houses face the street, their narrow porches tucked under the short gable end of the roofs (|). And most of these might be better thought of as "shotgun-like."

The fact is most houses in Boylan Heights are hybrids of pure types. Descriptions like "Colonial two-story Box, Bungalow elements: full façade porch" abound in the neighborhood's application for inclusion on the National Register of Historic Places. This reflects not only the stylistic marginality of Boylan Heights—indeed of Raleigh and of the South—in the architectural history of the U.S., but also the reality that, except for Montfort Hall, houses in Boylan Heights were not designed by architects, but by their builders.

This is all to say that we can read Kelsey and Guild's experiment in social engineering in the roof lines. For if it's true that all three (mostly hybrid) types appear throughout the neighborhood, it's no less true that a glance suffices to appreciate the preponderance of Xs (and its variants) at the top of the hill (where the covenants stipulated that at least $2500 be expended), of the |s at the bottom of the hill (where there was no bottom to how little you could spend), and the —s in between (where at least $2000 was required).

There are many ways to appreciate the structure of Boylan Heights' diversity. Roof lines are not the least.

X HIP ROOF

— GABLE ROOF, long side to street

| GABLE ROOF, gable end to street

SHOTGUN, BUNGALOW, MANSION

The characteristic Boylan Heights house is a mutt. Some shotgun, some bungalow, it's a white, wooden, one (or one-and-a-half) story house on a red brick foundation with a front porch and wooden railing. While there are variations and differences between the houses at the top of the hill and those at the bottom, there is also an organic coherence among them.

Kelsey and Guild's restrictive covenants endowed the neighborhood with a deep structure in the way the houses *mantle* the hillside: the mansion on top, its finial the finial to the whole hill; the stately houses around it, *solid*, but free of the extravagances of the mansion; then, as you begin to slip down the hill, houses with less *heft* until, finally, it's rows of shotgun houses on long narrow lots at the bottom. The subtle modulation between the houses along this gradient and their quiet conversation don't eliminate the distance between them, but do allow you to imagine bridging it.

The map displays the typical Boylan Heights house which we determined by analyzing a mass of data we collected on every house in the neighborhood. The tighter a house hews to this norm, the taller the oblong (whose plan indicates the size and shape of the lot the house sits on). It's easy to see that large lots precipitated distinctive houses that deviated far from the norm. The shallowness of the oblong on the mansion site marks the distance between its architected form—designed by the English architect William Percival—and those of the tall oblongs lining South Street innocent even of an architect's passing glance.

Housetypes

the taller the oblong, the more typical the house

this is the size and shape of the lot the house sits on

large lot, atypical house

long, narrow lot, typical house

long, narrow lot, atypical house

STORIES

The tall oblongs along South Street and Dorothea Drive obscure the reality that these are the neighborhood's shortest houses. Broken out here, then, are the number of stories a house has: it's easy to see that the higher on the hill, the taller the house.

1 1.5 2 2.5 3 stories

SIDEWALK GRAFFITI

Scratched, scrawled, or stamped into drying concrete—mostly from the 60s into the 80s—is a fragmentary and tragically conventional body of folklore. The mostly staid graffiti is testimony to the middle-class proprieties desired above all else by Kelsey and Guild and by the Greater Raleigh Land Company that hired them—in 1907.

WORDS

The graffiti is not the neighborhood's only text. There's other writing on pole tags, conduits, gas meters, and mail and traffic control boxes. The graffiti is not even the only literature underfoot. Where underground meets air sprout genres of signage: manhole, phone vault, and water meter cover, each scarred with its unique history. A few are as old as the neighborhood, others were installed much later, and the changes in function and style constitute a history. Trod on, driven across, paved over and dug out, lifted up and dropped, each records in its surface the unfolding of the process-thing that is Boylan Heights.

Kinsey left down Cabarrus cross Cabarrus to Florence

Right on Dorothea cross Boylan continue down Dorothea

turn right on Cabarrus turn right on South

turn left on Boylan turn left on Lenoir cross Cutler continue on Lenoir cross Cabarrus

continue on McCullough turn right on Boylan turn Right on Cabarrus turn right on Cutler

A SOUND WALK

The Sounds

- traffic
- voices
- hammering
- dog bark
- car radio
- pots and pans
- broom sweeping
- signs squeaking on pole
- PA at gas company
- small airplane
- bird cooing
- squealing brakes
- windchimes
- television
- individual insects noises
- saw company noises
- cans clanking at oil company
- drone of insects
- kids drumming on wrought iron pillars

The Route

right on Lenoir cross Lenoir FLORENCE cross South
 sec 480

cross Stokes continue down Dorothea
 sec 960

cross Stokes continue down South cross Cutler continue down South
 sec 1440

continue down Lenoir turn right on McCullough
 sec 1920

cross McCullough continue on Cutler turn right on Mountford sec 2400

WIND CHIMES

When we did the house types survey, we also paid attention to the presence of wind chimes. They were all over—bamboo, glass, shell, metal tubes. Depending on where you stood, the force of the wind, and the time of day, you could hear several chiming, turning the neighborhood into a carillon.

RADIO WAVES

Unlike the wave fronts of wind chimes which—requiring a lot of energy to move the air molecules—never get very large, radio waves don't propagate in air. They propagate in space and travel undisturbed through non-metallic objects like house walls and bodies. Depending on the location of the transmitter, their wave fronts can be enormous, yet they pass through the neighborhood silently, unfelt, and unnoticed, unless tuned into.

In the mid-1980s, Boylan Heights listened mostly to a mix of Top 40, Oldies, Country, R&B, and talk radio on six radio stations: WDGC transmitting from Pittsboro, WFXC from Durham, WQDR from Apex, WRDU in Middlesex, WRAL and WPTF from Auburn. As the neighborhood has changed, so have the radio stations it listens to. Today, it's mostly NPR broadcast by WUNC in Chapel Hill.

In the key, Boylan Heights is the point of tangency of these six fronts of radio waves. On the map, you can see which waves belong to which stations by their shape and direction. Because radio waves are concave to their point of origin, a wave concave to the lower right (southeast) is coming from Auburn, and one concave to the upper left (northwest) is from Durham. The degree of curvature depends on the size of the wave front and its distance from the source: the straighter the line, the farther away the transmitter. (Sensible curvature decreases with size which is why the earth seems flat.) These wave fronts, ever expanding, make different patterns in other places.

Radio waves also come from the stars. Their wave fronts are effectively flat and they come from every direction, silently, unfelt, and unnoticed.

Stations transmitting from:

BARKING DOGS

Barking dogs are anything but silent, their wave fronts anything but flat.

DOGS

Here are the neighborhood's dogs: given-names where volunteered, species where offered. If "dog" just the one; if "dogs" at least two.

They're the 1975 dogs and none of them may have been among the ones barking when those were mapped in 1982. Dogs die. People move in and out. Boylan Heights never stops changing.

Lucy

DOG Tipsy
CHIHUAHUAS

Brandy, Caesar,
Katie, Edith, Cleo,
Candy Lightning
Duncan
Sunshine
Goldie Coco,
Scottie

Homer
DOG **DOGS**
DOGS **DOG**
DOG **DOGS** **DOG**
Rolfi **DOG**
DOG

Ben,
Ginger
SCOTTIE **DOGS**
DOGS
Trigger
Rusty

Hot Pants,
Christie
Brandy, Jake,
Rufus Sam
Tiny Yukon, Princess
Frisky
DOGS
Mona
Ginger Joe Snooper
DOG
Zeus
Blackie

BORDER COLLIE

VIEWSHEDS

This is what you can see from Boylan Heights. The view captures the downtown skyline in the east and reaches the next ridgeline in the west. Views northward are blocked by nearby buildings and trees, except along the sightline opened by the railroad cut to the northwest. To the south one can see Dix Hill but nothing much beyond it.

"Viewshed" is a term formed by combining the "-shed" from "watershed" with "view," so, not an area draining into a particular body of water but the area visible from a particular vantage point. Viewsheds are used a lot in planning and development to maintain vistas and hide obnoxious features.

To make the map, I stood at each street intersection and mapped what I could see onto sheets of tracing paper laid over the U.S.G.S. topographic map, *Raleigh West*. All twenty-four of these were overlaid to create the aggregate public viewshed (no views from the second story of the mansion). It's also the summer viewshed. In fall you can see a lot more of Dix Hill.

FLOWERING TREES

All trees flower, all the angiosperms at least, the deciduous trees, the broadleafs. The oak's catkins in Boylan Heights in the spring are a yellow rain, its pollen a cloud of gold. The maples blush red; soon afterwards their green seeds spin through the air.

They all flower, but they do not flower alike. The flowering of the oaks is magisterial but that of the dogwoods is modest. Trees we think of as flowering have a human scale. You can stick your head among the branches of a crabapple and hear the humming of the bees in its blossoms.

At the height of summer the crepe myrtles draw a line of watermelon red along the streets. In the fall their rufous leaves litter sidewalks like celestial change.

X	crepe myrtles
O	dogwoods
■	small rosaceous trees (apple family)

AUTUMN LEAVES

I walked through the neighborhood at the height of color and used Prismacolor pencils to fill in a fine grid with the colors I saw.

 RED
 RED RED
 RED RED *green*
 RED *green* OCHRE purple
 buff green orange
 olive olive mottled *green*
 green OCHRE *purple* *green* *purple* *green*
 olive orange **yellow** **yellow**
 olive **RED** *green* **yellow** purple
 olive **yellow** greenish yellow *green* mottled **yellow**
 olive **GOLD** *green* **GOLD** **RED** *green* **GOLD** orange
 mauve **green** greenish yellow *green* olive *green*
 buff green purple **GOLD** *mauve* purple **lemon**
 olive mottled *green* mottled olive **RED** *ruby* purple *green*
 greenish yellow olive **yellow** marigold **GOLD**
 olive *green* *green* OCHRE purple greenish yellow orange purple
 olive purple *buff green* **RED** *mauve* purple tangerine mottled
 GOLD *green* dappled **GOLD** olive **yellow** olive *green* *green*
 purple *green* purple mottled **yellow** clotted *green*
 bruise **RED** greenish yellow *mauve* *green* *green* purple greenish yellow
 RED *green* **yellow** **GOLD** mottled *green* *mauve* marigold purple
 orange *green* chartreuse purple *green* **GOLD** greenish yellow **RED** dappled **RED** *green*
 mauve *mauve* **marigold** **yellow** greenish yellow mottled *green* *green*
 green clotted *green* orange greenish yellow dandelion marigold *green*
 green marigold purple *mauve* *green* greenish yellow OCHRE clotted chartreuse
 tangerine *green* OCHRE **RED** purple greenish yellow OCHRE chartreuse *mauve* greenish yellow *green*
 yellow OCHRE **RED** purple dappled *mauve* *green* olive
 chartreuse clotted olive *green* clotted **yellow** **GOLD** *ruby* OCHRE
 green orange mottled **RED** *green* purple *green* **RED**
 olive purple purple *green* **yellow** **RED** clotted purple
 yellow mottled greenish yellow OCHRE **GOLD** dappled mottled clotted
 GOLD *green* clotted *buff green* purple *mauve*
 yellow *green* **GOLD** *green* OCHRE OCHRE
 greenish yellow purple **yellow** greenish yellow clotted *mauve* **bruise**
 OCHRE *green* *mauve* **green** dappled mottled
 chartreuse *green* greenish yellow olive
 purple **GOLD** *mauve* **chartreuse** olive
 marigold **yellow**
 yellow *green* purple
 greenish yellow mottled olive
 dappled *green green*

THE AGE OF TREES

A bird's-eye view from 1872 shows an orchard surrounding Montford Hall and beyond it, meadows tufted with trees. Most likely, all of those trees, save a few around the mansion, were cut down to ready Boylan Heights for streets, sidewalks, sewer, and water lines.

This means the oldest trees date no earlier than 1907, and that most are substantially younger. Hurricanes and disease bring them down as does injudicious trimming and general idiocy: some guy on Cabarrus had a lovely sweetgum cut down—in its prime—to stop the gumballs dropping on his Corvette.

∘	recently planted trees
○	saplings
○	young or adolescent trees
⬡	mature trees
⬡	old trees

TREES BY SIZE

 The neighborhood's streets are lined with stumps and very small trees. Look at the way they pick out Dorothea Drive, South Street, Lenoir, Cutler, Boylan, and Kinsey. They even pick out the lower block of Florence, so often invisible on our maps.
 The larger trees stand back from the street, out of the reach of Asplundh's saws. Some block interiors are filled with big trees. In the summer it can be 8°-10° cooler back there.
 The maps are great for probing the relationship of people's habits, electricity, overhead wires, streets, and trees. But when it comes to describing the majesty of a great old tree? Maps aren't much good at that.

⋅	stumps
▪	very small trees
✸	small trees
✳	medium trees
✳	large trees
✳	very large trees

THE MAGIC TREE MAP TRANSFORMER MACHINE

The neighborhood trees are like neighborhood kids: they all grew up here. Of course, we also know the trees are part of the greater Raleigh forest which is but a piece of the great Southern Hardwood Forest which is . . . Suffice it to say, all the trees in the world are related. If you go back far enough, we're related to the trees too. But this is to speak of trees *in general*. Once we relate the trees to their immediate environment (to a particular history of planting, nurturing, neglecting, cutting down—i.e., to the saws of Asplundh), then we can see patterns (Public & Private Trees, The Age of Trees, Trees by Size) that are utterly unique to Boylan Heights. And we can see how unique an individual tree might be.

1. All 1171 trees are on this map (it's the same as the previous map, Trees by Size).
2. All but the "large trees" have now been removed.
3. Here's a *new* map just of oak trees (willow oaks, water oaks, Southern red oaks, Darlington oaks, and white oaks).
4. Use the oak tree map to filter the map of large trees: all of the large oaks have been circled to produce . . .
5. A map just of large oaks.
6. Now, the "front yard" variable in Public & Private Trees (p. 81) is used to circle all the large oaks *in the front yards*.
7. This gives us a map of large oaks in front yards.
8. The observations used to make Disfigured Trees (p. 45) contained two other variables—"good condition" and "location favorable-to-full growth"—which are used here to circle those large oaks in front yards that are in both good condition and a location favorable to full growth. This turns out to be *all* of the oaks in the front yards.
9. Then, using the oak tree map as a filter, you can circle just the water oaks.
10. This gives us a map of large water oaks in front yards in good condition and in a location favorable to full growth.
11. Then eliminate the one tree, though in good condition, that suffers from some Asplundh side-trim (by referring back to Disfigured Trees). We now have a map of large water oaks in front yards in *absolutely* good condition and in a location favorable to full growth.
12. Finally, use the data from The Age of Trees to yank the young tree and the old tree. This gives us a map of large mature water oaks in front yards in absolutely good condition and in a location favorable to full growth. Aha! There's only one of these, the magnificent water oak at 901 South Street!

INTERVIEW WITH DENIS WOOD
BLAKE BUTLER

BLAKE BUTLER: In the introduction to *Everything Sings*, you mention how Mercator's idea of the atlas was this "cosmographical meditation of encyclopedic proportion," meant to contain everything, but instead, it became a reference manual, an apparatus of supposed fact.

DENIS WOOD: Mercator had this idea of making a gigantic "cosmographical meditation of encyclopedic proportion" on the universe; that was a huge desire of his, but it wasn't connected to any obvious commercial outcome. But from the very beginning, he sold the maps. And when he died—he died before the atlas was ever finished, before even the map part of the atlas was finished—the plates were turned into commercial gold. It happened really rapidly. They sold like crazy. So it's about selling paper, and the things they can sell most easily are these maps. They're decorative, they're informative, and they're modern. They go through edition after edition after edition, and they are still being printed and published. So I think that's what happens: the great glory of writing the encyclopedia of the universe is this mad, delusory dream, whereas maps are a way of turning industrial cellulose into money, by printing information on them, and selling them. Mercator was going to have a chronology of world history, a chronology of ancient history; he was going to write ancient history; he was going to have all kinds of compendia. It was really going to be this gigantic thing that would've been a commercial impossibility. Nobody would have bought it.

BB: It seems like—particularly in *Everything Sings*—even if you lived to eternity you could make new maps constantly and never really finish. It's an endless cycle because certain of the maps—for instance, the map where you document the color of the leaves on a particular tree in the fall—you could come to that tree every year and it would be different. The amount of information out there and how you parse it are unending.

DW: It is endless. In *Everything Sings*, it's endless for this little, teeny piece of territory, but it's far more endless if you want to do anything much larger, for the world. That's ridiculous. Weather maps are being updated less than hourly at this point. That's continuous, ongoing, real-time mapping. And the number of maps that are produced is totally insane. But what's climate? Climate is long-term weather. And of course our climate knowledge is compiled out of daily and, increasingly, hourly records of the weather, everywhere. That's how we get climate. Same thing for traffic patterns. So it's being archived, and the results of these archives are these higher levels of what we think about as knowledge. Instead of weather, we have climate.

BB: When I first started looking at *Everything Sings*, I was thinking about how people always say, "a picture is worth a thousand words," and I had always thought that that was an asinine statement. Because the whole value of a word is that it represents something that is not picturable—it enters your brain in a different way than a picture. But a map is somewhere between the picture and the word. Your statement that "A map is an argument" is really intriguing for that intersection.

DW: If you compare Google Earth and Google Maps, for example, Google Earth in its naked, unlayered form is a bunch of pictures. They're not maps. You have no idea what you're looking at, and to the extent that you *do* have some idea, it's something you're bringing to the image. Pictures and words don't have anything to do with each other. If you look at Google Maps, on the other hand, or an annotated version of Google Earth, which turns it into a map—there's a label that says this is a desert, this is a mountain, this is a river, this is Kazakhstan, this is Mongolia—well, that's what makes a map something other than a picture, and I think it's one of the key problems in people trying to think about what a map does or what a map is: they see through the layer of words on the map to what they imagine is the landscape.

That is to say, when I say "see through," it's like the words aren't there. The words are so taken for granted that they become melted onto the landscape like cheese onto bread in a frying pan, and then people can't take them apart anymore. They don't realize that they're seeing somebody's interpretation of those marks. They say, "Oh, that's a mountain," because it says "Mount Ararat," or whatever. And that's what the map gives you: the map gives you the human landscape as opposed to the land. It doesn't give you the land. It gives you a human eye of the landscape. A photograph does that through its selectivity and its bandwidth, but it doesn't give you much. It gives you much less. A map is all about naming and claiming and saying what things really are. There's a huge arrogance that's built into the map, that "we can name and claim."

BB: One of the things that you say in this book is "signs are for strangers." Like if you live there and the place is part of you, you don't need the sign to tell you, "This is Walker Street."

DW: Right, you don't. The signs are for strangers, and that's one ostensible aspect of it. Another aspect of it is that you don't need to have the street sign, but you need the number on your door, so it can be attached to this grid so that the mailman can deliver you the mail, or the bank can foreclose on your property appropriately.

BB: You've referred to the presence of signage as one of the big shifts in maps. They're leaning away from narrative and toward data because people begin to look more at the language and symbols rather than the terrain, which makes it odd to translate from representation to reality when you are out walking around in the world.

DW: And you could walk around and not know the names of the streets and not care because you're just wandering around. You get to a new city and you leave the hotel; you've got two hours before something happens, so you just wander around. You don't pay any attention to any names of the streets, but you conserve a memory of turning left or turning right, or some landmark in sight. You don't need to know the names. You don't know what the buildings are. Then you might say to somebody you meet for dinner, "Wow, there was this really interesting building that I saw, and it was this and that," and your dinner partner says, "Oh, that's the Seagram building," or whatever, and begins to attach words to it, and a history and a story gets piled onto it. You didn't need that when you were just walking around, but you do need it for everything else: for building it, and addressing it, and documenting it: all of those things require words. We're really talking about semiology, you know. The sign doesn't speak for itself. This is one of the great shibboleths of both maps and graphics in general—the idea that there is this universal language they speak—but that's so much horseshit. There is no universal language. They all need to be read and interpreted.

BB: If someone who didn't have any previous knowledge of the language came across a stop sign, they would just walk right past it. Or it might just seem like an object of terror rather than convey any concrete meaning. Have you read John D'Agata's *About a Mountain*? It's the story of Yucca Mountain, just north of Las Vegas, where they were planning to bury an enormous amount of toxic waste. He writes about this coalition of people trying to decide how to demarcate this mountain—ostensibly filled with toxic waste that 10,000 years from now will still be dangerous to people. They're trying to come up with a sign that will still be meaningful to someone who has no understanding of our language now. That kind of aura is inherent in a lot of maps here, in which so much is measured and language is clearly surpassed.

DW: Right. They had a similar problem when they sent that plaque, the Voyager Golden Record, out into the universe on the *Voyager* shuttles. They had to figure out some way of communicating with entities that don't know language. They struggled to come up with these signs that would be somehow meaningful anywhere in the universe. [*Laughs.*] I find these projects so delusory.

You know, one of the things I cheated on when making this atlas is a lot of the maps don't have any words on them. But they don't have words on them because they are in a sequence of other maps, which do have text associated with them. If you were just to show the pumpkins that are on the cover . . . I mean, what the hell is that? There's no way of knowing it's a map. It only becomes meaningful in the context of all of the other maps. So the idea of the atlas as a structure that gives meaning to individual maps—which I also write about in the beginning—is essential to this project. Otherwise all of these maps would have to have little labels on them, and the pumpkins would have to have addresses on them, but that is so far from the point. We are people of words, and we think in words, and that's how we know the world through words.

BB: Another idea I found interesting in *Everything Sings* came out of your statement, "Any order will give rise to narrative." To me, the more interesting narratives always come out of letting the smaller pieces intuitively or structurally speak for themselves, rather than speaking *for* them. I'm always skeptical of people who are too possessive of that ego that they *created* something. The human as a filter is, I think, more interesting than the human as an ego.

DW: As a geographer, I continuously focus on the material idea of a person, on where the person literally comes from—that is to say, the lettuce from California, the beef from Iowa, and so forth and so on. I want to see the person trailing these sort of fibers of connectivity off into the universe so that we can really see the individual as somebody who comes together momentarily out of a whole bunch of things that are tied to the world in many complicated ways.

When I was a kid I read Walt Disney's *Our Friend the Atom*. It had an image of Leonardo DaVinci breathing and having so many atoms of oxygen pass through his body in his lifetime, and these things are exhaled and they get caught up in the atmosphere, and the stochastics of thermodynamics means that they get spread all over the place. So, every time you inhale, you inhale 200 atoms that were part of Leonardo DaVinci's body. As a child I'm like, "Holy god! What does that mean? Does this mean that Leonardo DaVinci is dispersed?" And yes, it does. In an atomic sense, he is literally dispersed into the universe. There's that wonderful image in one of Philip Pullman's *Golden Compass* books where they let all the souls out of purgatory. They go down to purgatory and open the back door and let all these souls just slip out into the

universe, and as they slip out into the universe, they're dissipating, of course, and then there's nothing left of them at all, because there is no heaven. That's one of Pullman's points. And as they move to this point of dissipation, they all acquire a kind of beatific *thank god, I finally get to dissolve myself into the what-all of the universe*, whence, of course, they came. The whole idea that "I'm me" is preposterous.

BB: A lot of these maps were made using information that others helped you gather, correct?

DW: Most of these maps were done in class, with students.

BB: So you're working with a team of other people basically to make a portrait of a place where you spent a large part of your life.

DW: I lived there for twenty-five years. My kids grew up there. It's a portrait of that place in maps. But I also thought about it from the very beginning as something else. I'm a geographer, and it's true that I was teaching at a design school. That's one reason I think the maps are so much cooler than maps that come out of geography programs, because design students have a need to declare themselves in graphic form, whereas the cartographer has a need to make himself disappear in graphic form. The scientist, yes, wants to say, "I had this idea," but he wants to pretend that he is merely a conduit for the data which he was smart enough to identify. He makes some claim on it that allows it to be attached to his name, but basically, it's the data. "This is the real world! This is true!" is what he's saying. Whereas a designer, he's coming from a wholly different perspective. He's saying, "This is me."

Besides that, I wanted to think about what a neighborhood is. What makes a neighborhood a neighborhood? What are the characteristics of neighborhoodness? There's a theorist named Leonard Bowden who had the idea that neighborhoods are created by eleven-year-old preadolescent males. In their running through the neighborhood and connecting families together, crossing fences, going into homes that their parents wouldn't go into, and knowing people that their parents would never even acknowledge, they create the neighborhood. Not girls, because girls were not given the privilege of ranging like the boys were, and not older boys, because they were being directed by the school toward classmates at a distance.

Now, that's just one idea of how you can think about what pulls a neighborhood together, what gives it its identity, its structure. What the students and I came up with, working with these maps, was that what the neighborhood did was transform the human being who is a citizen of a city into this individual who lives in this neighborhood, who has these kinds of relationships with these kinds of people, who sits in this particular way on his front porch in the morning when the sun shines on it. At the same time, it takes that limited individual and turns him into a citizen participating in this much larger social structure—a social structure that's too large for anybody to get his head around. So there's the neighborhood itself, the making of the portrait of that place, the theoretical concern about neighborhoodness in general, and then this third strand in which the shape and nature of the map embodies the qualities of this place called the neighborhood.

BB: What about your colleagues in the world of mapmaking—is there a big clash between you and more traditional geographers who are making maps to sell in books of data?

DW: Many people don't like my insistence—which goes back into the very early 1980s—that maps are political, that maps exhibit and

promote a political orientation. They're *about* something. They have an agenda. There are a lot of mapmakers who really object to that. And this is in 2011, when my colleagues and I have been at this critical thing now for twenty years, which has largely been accepted. It's the new cartographic dogma that maps are interested and have perspectives and make arguments and things like that. But when I say at a meeting of cartographers that maps aren't representations, it's very usually the case that the first person who stands up to ask a question says, "How can you say that maps aren't representations?"

Also, a lot of them don't want to acknowledge any complicity with the way things are, and maps have a huge deal to do with the way things are. They want to pretend their hands are clean: it's just a tool. But you can do bad things with a tool and you can go good things with a tool. I've been suggesting to the hardest-edged people of all that they could put their epistemological and ontological arguments on a really firm foundation by simply acknowledging the fact that they are making the world. And they recoil from that, viscerally and instinctively, as they continue to make the software that enables them to make the world. In explicit terms, some of the most brilliant analyses of how maps do what they do have been carried out by these people who are basically building machines to make maps. When someone drops a bomb on something and kills a bunch of kids, and they do that using a map that you made, you either accept the responsibility for it—a kind of *well, you can't make an omelet without breaking some eggs* responsibility—or you say, "Damn it, I can't do this anymore."

BB: The maps you make in *Everything Sings* exist on a more personal terrain than a war map. I wonder whether the process was ever potentially emotional for you. I imagine a map could even be terrifying, even—revealing certain things based on information you collected, about this place where you lived.

DW: The problem with making the map is by the time you've decided, "This is something that constitutes data," and you've collected it, and you've massaged it to the point where you can make a map out of it, you already know the worst that's going to come out of the map. When you're working at the scale I'm working at, you've already decided up front that you're going to record locations of wind chimes. Now, it might be somewhat of a revelation to actually map them out, but it's not going to be shocking or anything.

But I've seen maps that I find completing terrifying. Uranium minings and various illnesses in the Navajo reservations—they're just insane. They just make you furious. Bill Bunge's map—that I still think is one of the great maps, the map of where white commuters in Detroit killed black children while going home from work—that's a terrifying map, and that's an amazing map. He knew that. They had to fight to get the data from the city. They had to use political pressure to get the time and the exact location of the accidents that killed these kids. They knew what they were looking for. I didn't have anything to do with that project, so when I saw the map for the first time, it was like, Oh my god. It's so powerful to see maps like that. That's the power of maps, or one of the powers of maps: to make graphic—and at some level unarguable—some correlative truth. We all knew that people go to and from work. But to lay the two things together reveals something horrible.

BB: It's an argument, like you said.

DW: It sure as hell is. Maps are just nude pictures of reality, so they don't look like arguments. They look like *Oh my god, that's the real world*. That's one of the places where they get their kick-ass authority. Because we're all raised in this culture of: if you want to know what a word means, go to the dictionary; if you want to know what the longest river in the world is, look it up in an encyclopedia; and if you want to

know where some place is, go to an atlas. These are all reference works and they speak "the truth." When you realize in the end that they're all arguments, you realize this is the way culture gets reproduced. Little kids go to these things and learn these things and take them on, and they take them on as "this is the way the world is."

BB: It's interesting the way the interpretive layers that aren't pictured or quantified on the map exist there to uncover or to be told about.

DW: There are a thousand stories for almost every one of these plates. For instance, in order to get the photographs for the pumpkin map, I had to whip through the neighborhood on my bicycle because otherwise it gets too late—the candles go out or the people go in. So I'm on my bike at the eastern edge of the neighborhood, and I need to know what time it is. I ask this young guy in a phone booth, "Do you know the time?" He says, "Oh man, it's 8:30. I'm carving this pumpkin, it's probably too late." And I said, "Carving this pumpkin?" [*Laughs.*] That was really interesting. I'd photographed almost the entire neighborhood; this was the edge. He invited me to see his pumpkin, so we go to his house, and there's no pumpkin on the porch, there are no Halloween decorations, there's no sign that if anybody knocked on the door they'd have anything to give them. I park my bike, we go into the kitchen, and he's got the pumpkin sitting on the drain board of the sink. He's carved out a mouth and a nose, but he can't figure out which direction the eyes go. That cultural cue isn't somehow built into him, and he's paralyzed. He'd left the house to call a friend to find out how he should make the eyes. I knew there was a concentration of pumpkins around the part of the neighborhood that I lived in, but I didn't realize until then that there were big spots in the neighborhood without a single pumpkin. When I met this guy, I realized that the pumpkin was, in a way, a representation of cultural capital of some kind. You were tied into the culture or you weren't: you saw the pictures, you made the paste-up things in elementary school, you paid attention, or you didn't—and then you didn't know how to carve a pumpkin face. That's what I was looking at in this map: marginality. Then, when I made the map of how many times different addresses were mentioned in the community newsletter, I said, "Oh my god, the marginal pumpkin areas are precisely the areas marginally mentioned in the newsletter." And guess what? They correlated perfectly to assessed property values and the Kelsey and Guild plan to lay out a neighborhood with stratified class structure. All of these things just piled up. There were a lot of keys to open various portals, and one of them was running into this kid who couldn't figure out whether to make the eyes go up or down. And we all know the eyes go up. [*Laughs.*]

BB: Is there anything you think of as unmappable?

DW: To map something meaningfully, it has to have some kind of areal expression. It can't be uniformly dispersed in space. The USGS maps everything in the United States and it doesn't matter. There's a famous USGS sheet—maybe there's more than one—devoted to the Great Salt Lake. It's completely blue. There's not a differentiating mark whatsoever. It's just water, right? That's obviously preposterous. Only somebody obsessively compiling the universe would produce a map like that. If the phenomenon is differentiated spatially, then it can be mapped. And if it can be mapped, I guess the question would be: can you find and collect the data that would differentiate the phenomenon? And is it worth making a map of? Is it something that's interesting? To answer your question, no, I don't think so. I think mapping things is usually good. It lets sunshine in, though I suppose there plenty of microbes that don't like the sun.

IN THE HEIGHTS
ALBERT MOBILIO

An arrowhead. Edges chipped, point blunted, asymmetrical: the Heights as seen from above, as drawn on paper, as mapped by cartographers. An arrowhead, unburied and spiked with streetlamps, trees. Written over, driven across, strung with chimes and fences, trod through, dug up, and decorated. The shape of the place: a point, a push toward. The shape of the place: its people.

On corners in grocery lines or high above them. Same thing? Both views simultaneously? The traveler feels that way, as if the streets were both walked on and flown over. Heels rocking on the curb's edge, summer stars over the cement factory, bright bursts light years away in the treetops. This is how the traveler dreams himself in passage: bound by earth yet lifted up. A journey done in a single glance, or giant steps. Great thunderous shoes are wings. Starting from the middle, from this station called *among*, so the walking goes.

Long ago shovels and pickaxes once heaped up rocks and stones. He scuffs against this man-made ridge, making his way toward the top. There's always such a point, some uttermost where the gradient lines converge in nervous proximity. They vibrate with expectancy, with the breath-demand of elevation. Coolness moves around the traveler's arms and chest as he draws close and even closer. Where the topographic lines clench there's a mansion from which every eye looks down.

Pipes, trees, phones, and birds' nests in the wires. Power and light. Pipes, trees, phones, avenues, and nests. Only connect, the traveler thinks. She draws on her water bottle and unfolds the paper to count what she sees in its creases. The miles are small here, but they are so crowded. Under these minutely etched leaves her senses grow accustomed to shadow and to its watery scent.

Dorothea, Cutler, Mountford. Stokes, Dupont, and Florence. Lenoir and Boylan. Kinsey and Carrabus. To is the same as from. There is a system to this way of moving. Make a left, take a right. He breathes to animate the arterial flow. Some prehistoric stream beneath him; above that—routes now laid out in asphalt. Steam rises from the black surface when morning comes and mingles with handheld sounds. Downshifts, screen doors, and jangled keys. Particles of light blink at corners. School kids scuffle at bus stops. Sign says One Way. *But I'm only going one way.* And thus, the motorized garden awakes.

Bottles on the porch rail, the stereo's ecstatic. And then the cops came. Suspicions were exchanged, papers requested. A kid, the words *Real Rookie* on his t-shirt, was led between two officers across the lawn. The traveler feels excitement in the red light's pulse; at the edge of its halo, she watches drapes shift and shades lift just slightly. Doors close, locks are checked. She could hear whispers if she leaned into the breeze.

What happens tonight will be news in backyards tomorrow. The cops depart. Trees unspectacular now—ordinary rustling where shouts had risen through their branches like fresh pronouncement.

A traveler brings word from outside. Names written down and carried. A dentist is surprised to read a once familiar but almost forgotten address; a liar studies the address of the person he lied to; a cook reads a list he requested; a teacher reads a flattering plea; an ironclad believer opens an envelope to discover a snapshot of someone he doesn't quite know; a young girl who settled for an unexpected life says out loud the sum on a credit card bill; a scrupulously shaven man who never goes out discovers in a handwritten note another reason for staying in his chair in the kitchen by the window where he can smoke. Everyone, it seems, is easily found.

Whatever's left over is left out in back. Sofas, heaters, feeders, dead leaves, winter coats, wedding tapes, quadrants, rulers, empty cans, pineapple rinds, and utopian schemes scribbled on TV guide covers. Out back in the alley there are skin smoothing devices, chains, battleship models, oaths, knobs, stoppers, and various kinds of wood. Round mirrors and the rectangular sort; melody-makers, dice, hats that didn't quite fit, bras that did, newspapers, dog collars, pliers, peels, things burned, things moist, things left too long unattended. Items broken, accidently or on purpose; items labeled or scratched into; items bought and stolen; just plain shit. The alley is where there's abundance and multifarious waste. In the alley. Out back. No one sees what the neighbors leave, but each person knows their own discards and can recall its weight and the day it came into their life.

The traveler sometimes rides the bus. Her watch must be consulted because the bus doesn't wait. Just minutes to go and then she's a face in the window going by. The world is nearer from inside—she can look right into the houses, into cars, into faces at the windows of the other bus that passes her. The roof of the bus almost brushes low-hanging branches. The bus is vouchsafed, though. The bus has permission. A schedule. A destination. She rides as if borne high above the knockabout domain of sidewalks and streets where drivers and pedestrians choose at every intersection which way to go, always mindful that there are many routes, some faster, others less so. The traveler sometimes rides the bus: She daydreams about a balcony overlooking a smoke-colored town. Shouts can be heard; people hurry in the narrow lanes. Far-off clamor of deciding minds.

Fingertips press against night. His face not quite visible, he gazes up into the trees. Elongated pulse; the spark flaring. He cannot begin to know how far he's come. Effort is no longer legible at this degree of warmth. He reads distance in this smudge of white.

The dark slashed up by jagged mouths and three-sided eyes.

A compass needle spins, inscribes the sun under which the Heights bask. Everyone's included—the sky is well within anyone's reach. Shirtless man under the hood of a Buick LeSabre, the radiator cap giving way; a toddler, lotion hastily smeared across her back skips in a sprinkler; windows are thrown open, kitchen sounds through humming fans; two teenage boys scout two girls wearing tank tops, eyeing their slim shoulders that are as polished as epaulets; in a chaise lounge out back, a

grandmother stirs just one more pinch of sugar into her iced tea. Two, maybe three battleship-size clouds sail across otherwise spotless skies, their piled-up tiers lending a fearsome cast to their already epic bulk. The citizenry doesn't scatter; shelter isn't sought. A few deep breaths. Slap the hood shut, stir the tea; this portion of the planet realigns with its slice of the sun.

Where there are fences, the traveler pauses to inspect. The strong ones made of metal and wood and stone; others only gestural—pipes and string. She is wary being so close to them; strumming, as she does, a chain link with a stick or pressing her palm into the sharp board of a picket fence. Would an owner suspect she was contemplating trespass or perhaps testing the strength of the barrier for a future attempt? Doesn't the fact of the fence say Stay Away? How close can she stand to it before she raises alarm? Or is she making too much of what's really a decorative border or a means of keeping the family dog from running away? An almost palpable quietness is felt; her thoughts feel like the loudest thing on the street. Fences aren't meant to be touched or even much noticed. To even see one is to make it more than it is, she decides. Wind chimes sprinkle silver notes down the block; her stick rattles on the metal links. Yet her thoughts are still louder than either.

A ceremony is held and commemorated with an inscription: Jimmy & Jane. Kathy & Bob. Angie–n–J.L.W. Bobby Bobby Bobby. Billy + Ann. Messages scrawled in cement. The sidewalk is an altar or even a kind of gravestone. Whatever was joined together here is as permanent as things get. Jimmy and Jane were a popular couple until they went to different colleges; they're both retired in Arizona but neither knows the other's there. Kathy never really liked Bob; the graffiti was his doing. All through high school she avoided that street. J.L.W. had plans to join the Army but failed the physical; he and Angie went to the middle school dance and he hasn't seen her in decades, but still has the penknife he used to scratch their names into wet cement. And Bobby lives not far away. He smoked too much for too long; the wife left years ago and his only kid lives in Washington State. Billy and Ann, they're still together. Still in the Heights. And Ann's still mad he didn't spell her name right, with an e.

Arrowhead. Made of asphalt. Made of trees. Of streetlight and scrawl. Of telephone calls and shouts. Of wire, hedges, porches, stars, money, and stone. Of thrown away and kept close. Of his house, her house, the house where what happened happened. Trace the street names on the map, find your way into the place: An arrowhead. One shot out across decades, through the travelers. Their journeys. The bow is always being strung. The Heights are always just about to be lived.

EVERYTHING SINGS TRIPTYCH
ANDER MONSON

These three essays are from a project called Letter to a Future Lover, *a book, a box of cards on which are written short essays on small things found in libraries: a passage from a book, a striking image, a snatch of overheard conversation, a human hair, a punch card, homophobic marginalia, a packet of seeds, a due date stamp, just to name a few. These three are in response to Denis Wood's* Everything Sings *and were published back into the copies I was reading in the University of Arizona Poetry Center Library.*

EVERYTHING'S RINGS

A wet year in northern Arizona produces a large ring in the pine trees, and a dry year produces a small one.
—A. E. Douglass, "Tree Ring Dates and Dating of Southwestern Prehistoric Ruins"

Are you listening, Denis Wood? I don't know if you wanted to be mapped to Boylan Heights, but in my mind you have. Knowing it is knowing you. I still don't know the feel of it, of course, having never run its blocks, having never enumerated its trees and mapped them, as you have. But I know the way you've tried to understand it, to take it apart and put it back together: Boylan Heights, I say, and feel the wordsound in my mouth. Nothing happens when I say it. When you say it, though, something happens. It opens like a magic action. Splits itself apart into a dozen maps, then each of those, they separate, and keep separating.

Where I am from is still largely unwritten: zero for most of the world, a one for those who know it. Full of it even in absentia, we know it well: we know it's ours; we've made it so through hours of living in it, living through it. Everything is underground or undersnow. Everything is trees and water and diminishing summer. Everything is rings of trees and amateur radio waves blanketing everything, invisible, indivisible.

Everyone sings where I am from. The pain must take a shape. They shotgun the signs where I am from. That's percussion, a way of singing, too. Robert Pinsky says the medium of a poem is the body of the reader.

Everything's rings, a circle around where I'm from and where I am. We cannot get away from from. You know. Where we're from is where we're from. We can punch it down like rising bread but not shake its stink from us. From where we are we might think it silly, strange, that place of origin, why would anyone live there, fall in love there, fall in love with it? But what do we know? How can we plot how it rewired us?

Every sentence is a ping where I am from, bit pulse sent to test a circuit, check to see if someone or something's listening on the other end. The response could be a year or a century from now.

If you were to cut my life in half, you could read it by the rings it would contain. You contain them too: who you used to be is enclosed in who you are. Your old heart is not erased. It's encased in another heart, another axon-dendrite shell stacked, shellacked atop the old. We are a wasp's nest of selves, each embedded in the next.

It's okay to know. We can change our lives. Some of us do so dramatically; some unintentionally. Maybe we hit a guy walking across Speedway Boulevard, named the ugliest street in America by *Time* in

1970. Maybe it was dark; he was wearing dark colors; he was walking out, not in a crosswalk, occupied by a map. You were waking. And then the rubber marks tires leave on asphalt when they try to stop: they were left on you. They are still on you. What does it mean to say it was not your fault? Your old life is gone; it's covered by another—by the other's life you accidentally ended. This is a real fear of mine. Tucson, Arizona—the place from which this note is composed—is built of cars and grid of streets. Someone's always getting hit. Maybe it's the heat. That's a map. I fear that either I will go this way—hit from behind, skull opened to the sky, hand trepanning it to lowercase the swelling—or I will hit someone with my car, map their heart along its hood. You might see the ring a year later, a decade later: skid mark, blood, concrete, broken spoke, and fault. Go get a malted milk. It'll help replace that mouth taste with another.

Everything's stringed together like this: a read sentence suggests another. An essay leads us to a book, which contains a pair of hairs—one human, one pet—caught in a fold. As we know, each human hair contains a world of information and connection. Hair connects us to the animal world, in which we are driven by urges from millennia ago: sex, safety, hunger, satiety. If hair contains the curls of DNA then in it we are reproduced. We've mapped that, helpfully.

Everything swings, is singed, the burn circle out back beyond the barn in memory where my Estes model rocket set the whole field on fire and my cousin Jay had to be roused to put it out. Do you remember? he asks, when I see him. Yes, I say. I do. I thought the world would burn that day and would be replaced by another, darker one.

EVERYTHING'S SIGNED

This colophon serves as a certificate of authenticity. It is issued by Lisa Pearson, publisher, Siglio Press, Los Angeles, California, and is signed and numbered by the author and mapmaker Denis Wood.

—*Everything Sings*, Limited Edition, Rare Books Collection, University of Arizona Poetry Center Copy 2

Everything's signed by brain or hand or heart, Denis Wood. That signing is a map. Your hands were on this edition, in a room somewhere, your Boylan Heights perhaps, or in Los Angeles. In the age of disassociation and fragmentation, history-free eBooks torrented on the internet, burger meat from random cows gathered up in drive-thru fast food burger patties to be liked, live-tweeted as we eat, there's also this: a thing, an artifact, complete with Hancock and fingertrace, which makes it more than other books, we're meant to know.

Reading anything is a risk, rare books more so. This might take me over if I let it, if I open myself up to it. Left alone, I feel a double nervousness, an electricity, like I'm bound to slash I want to fuck it up somehow, fracture this life from the one before my error.

I hear about the fires in Colorado. Everything is singed there, I think, dinged with particles of smoke or fear of smoke, or thoughts about what smoke might mean if inhaled, if it spread toward the bodies of those we love who still live there. I wonder if Boylan Heights has ever burned. In my own Upper Michigan this summer was marked by fire. It was wet when I was there, but just a week before, it burned. The Seney Stretch, straight and long throat of road, often obscured by blowing snow in winter: driving it you see spaces opened up by blaze now just filling in with new.

Aficionados of prairie fire in Western Illinois understand that only in flame can new growth come. Sometimes one must burn a thing to make it live: it's not enough to build it up, to rehab and refurbish; instead it must be reduced to ash.

I'd love to torch your book and see what would come out. Would the pages curl and reveal a new map of Boylan Heights in char, or someplace else beneath it? Would the vellum maps of the limited edition, backlit for a moment before they conflagrate, align and open up the world? Oh, I recognize it's just a book. It has no secret name, no special powers. It's not the magic I once wanted hard to believe in. It's not sodium chunks liberated from the chem lab dropped in toilets at the high school just to hear the boom. It's not the towering flame of the stairwell sawdust column, scattered from four floors above and descending, lit from the bottom and burning all the oxygen that forced the school's evacuation.

I admit that was a bad idea. Collect enough of them and you can map my life this way. Maybe it's worth it just to have seen a thing like that, as if by force of thought and action we transformed an afternoon of school into a memory that still sings these decades later. That is a map of something, map to something, map to my former self, perhaps, and its weakness for vandalism. We signed that place in fire, or dreamed we did. And now it's gone except in memory, the high school moved, and what we thought we knew decayed.

Your maps sear the eye because they essay: they show—they are—a brain operating on the world. Through them we experience place—but also self as it sees a place. They venerate the I through the action of the eye. Boylan Heights is singed by you, what you saw there, what you made of it; it's signed by you, and that's what keeps us here with your inventions, your associations. Thus my Boylan Heights is bent beneath your Boylan Heights, and I'm happier for the pressure and attention, more aware of the constellation of jack-o-lanterns on my paper route along my own Woodland Road, age thirteen, before I moved away.

Pank the world into a flattened transposition, which is what we do in the North to snow: we can't get rid of it, you understand; we move it, or failing that, we pank it down with shovels into a flattened path which we might traverse with dogs or sleds, snowshoes, skis, stories, maps like this, memories of hearts, or other powerful machines.

*

FOR AN ODD GEOGRAPHER

The neighborhood: a metabolic machine.
—Denis Wood, *Everything Sings*

IN AN ATTEMPT TO REACH YOU AGAIN
—email message from "A. M. Garcia," informing me of my dubious $25.5 million bequest

Dear Denis Wood, after reading you, this year I've come to know the extent of the Tucson storm sewer system, the tunnels singing, pinging, underpinning the upper world. I want to know the Western sprawling city grid anew: so I follow where all the water goes when it monsoons. In August as I write this there is rainpound everywhere: the blank of air is filled with gush; streets flood and drain into the washes, gulches, arroyos, where they rush into the Rillito River, which winds into the Santa Cruz, and disappears north. Roads become unpassable; a bridge erodes; the city is reversed.

You come to know a layer of a place when you are there so long you forget what it was like above, when your senses adjust to what the tunnels offer: graffiti spray and bits of flotsam, trashed glass, traffic manhole cover clang, twists of wire on walls, the occasional insect scuttle sound, and, when raining, wet infinity.

Paint marks on walls make up a map of how far in you went, who was here and when, who fucked whom, who loved whom and when, until they didn't anymore. Who lied. Who died. Who rulez the skoolz; who adornz the Zs with a diztinctive zpray paint trail. These notes belong to the lonely, the homeless, and the young: who else finds their way into these secondary spaces?

Less than an hour away, you miners who plunder copper from the mountains south of Tucson: how do you understand the world beneath this world? Is it more than an economy to you?

A century and 1564 miles away, you Finnish miners who cut a living from the Copper Country of my childhood, on the border of Superior that borders Canada: what did you know, working your lives in the underneath? What was your world like without the sky for days, buying your own candles, contemplating the threat of gas or roof collapse or filling lungs, knowing that your need for light and a living had a cost?

Or you bored, gorgeous preening teens who broke the locks on the long-closed doors and explored the shafts with spray paint, beer, and radio, wanting something else from your isolated lives: what respite did that darkness offer you?

I think of light 5,899 miles away, in Vilnius, Lithuania, a city in which I rarely hear my language spoken. The library in which I work is dark, five centuries old and counting. Everything is ornate wood, made to be admired, not used. My laptop's on the huge reading table surrounded by banker's lamps, glass-encased Mercator maps, books of exploration, and a display of desiccated spices brought back from places exotic, east. Cinnamon and garlic, coffee, chocolate, cardamom, vanilla: the desire for these once drove (or financed) our explorations into the other, the open spaces on the map. What must it have been like to make your way away from the known and into the uncharted?

I know I'm drawing circles here, charting pairs, but isn't that what a map is for, corresponding thing with thing: that ridge; that colossal palm; the tallest, oldest pine in view; the spill of porch light on golden hair; a flash of underwear; a Rorschach blot; a dying wish; a dish-filled sink; the short-wave radio you could hear from there and there alone; oil-stain in a driveway; a border of a country; a hazy patch of memory?

In 1968 the Office of Charles and Ray Eames produced a short film, *Powers of Ten*, in which, starting from far out in space (scale of 10^{25} meters), the camera zooms in an order of magnitude each ten seconds on the center of the previous frame, to Earth of course, a couple picnicking just off Lake Shore Drive in a Chicago October, then inside the man's hand, his skin, deep in the cellular interior, ending (in this version; subsequent books pushed in further) in the center of a proton of a carbon atom. Much is known, we see, but more is not: on either end, the micro and the macro hold infinities. What is outside of us? What is inside of us? What is under us? What does the heart hold? What of the dark-adjusted eye? What of the brain, forever voyaging, making maps of what we know and don't?

APPENDIX

Most of these maps were made in a series of landscape architecture studios that I taught beginning in 1975. I co-taught the spring 1982 studio—in which this version of the atlas was initially conceived—with Robin Moore. Over the years a large number of students contributed to the project, but those who participated during the spring, summer, and fall of 1982, and in the spring of 1983, are essentially co-authors: Carter Crawford, Aurora Dee, Susan Edwards, Shaub Dunkley, Tim Hess, Jimmy Thiem, and Helen Waldrop. Carter, Aurora, Shaub, and Jimmy played especially large roles. However, the collaborative nature of the work means it is not easy to assign or assess the magnitude of credit for each map or photo. Increasing the difficulty is the fact that the files have been often moved and stuff lost. What follows is my best effort to say who did what and how.

Where Is Boylan Heights?

I set the type on our IBM compositor and Carter Crawford drew the map, made the mechanical, and shot the PMT. This is how most of the early maps were turned into final art.

These nearly forgotten technologies were very widespread in the 1960s, 1970s, and early 1980s. The IBM compositor—actually the IBM Electronic Composer—was introduced in 1966 as an adaptation of IBM's Selectric Typewriter. The Selectric, introduced in 1961 and better known as the IBM Golfball typewriter, allowed users to change typewriter fonts within a manuscript (or even within a word) by switching out the golfball. It made desktop publishing possible (which is what this atlas would have been had we finished it in 1982). IBM's Electronic Composer was a modification of the Selectric that could churn out camera-ready justified copy using proportional fonts. In the hands of an expert, it could produce results hard to distinguish from Linotype or Monotype output. It was a typewriter-like typesetting machine.

PMT stood for Photomechanical Transfer. This was a diffusion transfer process that, without the intervention of a negative, photographically turned camera-ready art (the mechanical) into a black and white image on slick, glossy paper. This could be burned to a lithographic plate or used as the original in photocopy processes (we planned to Xerox the PMTs).

The PMT process was incredibly forgiving and let us paste various pieces together—compositor output, stick-up type, different pieces of art—into totally kludgy, layered mechanicals. The mechanical was focused to size in a graphic reproduction camera, and a piece of PMT paper was exposed and developed. That was it. That piece of paper was the PMT, our final product, and the process flattened layers just like the merge and flatten layers commands do in Photoshop. In fact, Photoshop and Illustrator are in many ways digital analogues of these older technologies.

PMT paper was cheap, the process was simple, and its forgiving character emboldened us to try one thing after another, to pile on things, to take them away. These maps—the whole idea of actually producing an atlas—are inexplicable without these technologies. It helped that the School of Design supported them and encouraged our students (and faculty) to use them.

Aunt Marie's Map

My aunt, Marie Krawcheck, lived in Cleveland, Ohio, but she was in the habit of visiting my grandfather in Wilmington, where he'd retired in North Carolina. On one of these visits in 1979, she came to Raleigh to visit us, and when she did, I asked her to draw this map.

The Night Sky

The star map is a great example of how the production played out in practice. Opening the atlas in the stars was my idea; Carter and I together worked out how it would lay on the page; and Carter did the drawing, made the mechanical, and shot the PMTs. There were a lot of these. As you know, we started by laying on our backs, sketching what we saw on a pad held over our heads. This original sketch is on page 30. Drawing upside down in the dark was impossible, so the next day Carter returned to make a series of twenty-one overlapping field sketches that, after reducing, we were able to lay out in a circle thirty-six inches across. Carter traced this new drawing and painted everything outside the horizon black, reducing the drawing in sections in the PMT camera. Getting this right was an iterative process. Consulting star charts, he then laid out the stars—the

symbols for which we stole from Galileo's drawings in *The Starry Messenger*—photographically reversing them out over a screen; ditto with drawings of the light flares and the lighted windows. Finally, Carter sandwiched all the pieces together for the final PMT. We returned to Boylan Heights at each stage to make sure we were getting it right, not only the buildings and power lines around the horizon and the locations of the stars, but the feeling of looking at the sky in the summertime in Boylan Heights.

Nesting

Jane Norton compiled the data and made a map that I've modified and recreated in Illustrator.

Boylan's Hill

Our source here was Piedmont Aerial Surveys' *City of Raleigh Topographic Map*, 1952. Jimmy Thiem made the first assaults on the hill, producing a series of block diagrams surfaced with grids of varying fineness. We then made an illuminated contour map using Kitiro Tanaka's method, a process that generated a raft of transparencies and PMTs. At the same time we used the technique to make a contextual map of the topography of downtown Raleigh. I liked the maps, but we felt they lacked something of the handmade quality of the other maps we were working on, and Carter drew this one.

Intrusions under Hill

Aurora Dee and Tim Hess collected the mass of data we used to make this map from the City of Raleigh (sewer and water) and The Public Service Company of North Carolina (gas). There were no small-scale maps of these systems available at the time, so Aurora and Tim had to compile ours from large-scale engineering plans that dated to 1971. Tim made a number of maps of the individual systems, and Carter used those to make this map of the three systems together. Carter's map has been widely reproduced. Carter or Aurora took the photographs.

Squirrel Highways

Shaub Dunkley did the initial work on this map. Carter and I did the final fieldwork, and Carter drew the map. This too has been widely reproduced.

Trees in General

Shaub Dunkley made all our tree maps. He knew his trees and intended to field map every tree in Boylan Heights. Then he ran out of time. He provided the data for the reliability diagram which I made on the compositor. If we'd shot this as a PMT, the mask would have . . . disappeared. Because Shaub was also engaged in a special study of mapping and computer modeling, he entered all his data on each tree (location, species, size, age, and so on) into what he's described as "this washing-machine size monster in the computer simulation lab," then output the maps on a Tektronix 4662 plotter.

Broken Canopy

Shaub used a mid-1970s air photo to compile this map. I then produced it on the compositor. I really liked the idea of making maps on a typewriter.

Aerial View

I don't know who took this photo. Note that both the Boylan Avenue Bridge and Martin Street Viaduct are still standing, so it was certainly taken before 1982.

Disfigured Trees

Shaub Dunkley made the map and either Carter or Aurora took the photo.

Pools of Light

Carter made this map, the last in the long string of attempts described in the introductory essay. He also took the photos of leaf shadows cast on the sidewalks by the street lights.

Streets

Carter made the smaller map from the U.S. Geological Survey topographic map, *Raleigh West*. Aurora actually measured the streets, collected all the other data, compiled the map, and drafted it using adhesive tapes.

Footprints

Susan Goodman drew the map of south central Raleigh from which I excerpted this portion.

Signs for Strangers

Aurora compiled and drafted the map of traffic volume using adhesive tapes, from data provided by the Raleigh Department of Transportation or that I collected in 1981-82, sitting at corners, counting the cars as they passed. I spent many a day doing this. Aurora collected the sign data while she was working on her map of the streets. She also compiled the map which Carter then recreated. Aurora's essential contribution has not been acknowledged in earlier publications of this map in the Tang Museum's catalogue,

or in Jean Robertson and Craig McDaniel's *Themes of Contemporary Art: Visual Art after 1980* (Oxford 2005, p. 209). Aurora took the photograph.

Police Calls

An unusually large number of students collected these data from the Raleigh police department, and they compiled numerous maps. I made this one using Letraset numerals, a kind of dry transferable lettering. It had fallen apart, so here I recreated it in Illustrator.

Numbers

I made the map in Illustrator.

Mailman

Susan Edwards followed postman Tommy Rogers on his route and created this map from her observations.

Lester's Paper Route In Space & Time

The original route data was collected by Diane Pacella. Tim Hess compiled the map. I drafted the initial version of the space-time diagram which Aurora rendered in Zip-A-Tone. Here I've here recreated my draft version in Illustrator.

Two Routes

This too drew on the contributions of Diane, Tim, Aurora, and myself. Aurora took the photo of Lester.

The Paper's Route

I collected the garbage route data. Then, drawing on Diane's, Tim's, and Aurora's work for Two Routes, I drafted the time-space diagram which I've here recreated in Illustrator.

Alley Ways

Jimmy Thiem made this map with markers, the default drawing tool of contemporary landscape architects.

Bus Ballet

Jimmy Thiem collected most of this data and drafted a series of maps of the routes. Tim compiled the map of the neighborhood. Aurora Dee made a number of early space-time diagrams. I made the final map which I've recreated here in Illustrator.

Rhythm of the Sun

This is unvarnished insolometer output traced by a needle onto graph paper affixed to a rotating drum. The insolometer was on my porch roof. All I had to do was change the paper weekly.

The Light at Night on Cutler Street

Carter and I took hundreds of meter readings at night in Boylan Heights, but that map is too detailed to reproduce at this scale. For this block of Cutler, we took 151 readings. I interpolated the contours and made the map in Illustrator.

Absentee Landlords

I originally made these maps using Letraset numbers to indicate the number of properties owned, locating the numbers at the addresses to which the property tax notices were sent. I used 1982 data from Wake County. Recently I made this version in Illustrator.

Local Rents

Jimmy Thiem made this map using 1982 Wake County data. Carter or Aurora took the photograph.

Families

In 1975 the students in the first atlas studio fanned out across Boylan Heights to ask residents a series of frankly intrusive questions about everything from radio listening habits to pet ownership. These students collected the remark by the janitor's wife. The other data were compiled by the City of Raleigh in 1974. I made the map in Illustrator.

Assessed Value

For the assessments, I used 1982 data from Wake County. I made the map by smoothing the values of 333 residential lots across a 281-cell grid and then interpolating contours across the grid. I then glued strings to the contour lines, and made a rubbing of the strings.

Newsletter Prominence

I assembled the newsletters, extracted the data, and drafted the map using Zip-A-Tone screens.

Jack-O'-Lanterns

I rode through the neighborhood on my bicycle, stopping to take a picture of each pumpkin on a porch (and a couple that were still in kitchens). I then printed them as contact sheets, cut out the pumpkins, and glued them to a sheet of black paper at the addresses where I photographed them.

Public & Private Trees

Shaub Dunkley made these maps, again printing them on the Tektronix 4662 flatbed plotter.

Fences

Helen Waldrop collected the data for this map, compiled, and drafted it.

Roof Lines

Carter, Jimmy, and I carried out the door-to-door survey to collect the data. I carried out the analysis and reproduced the map in Illustrator.

Shotgun, Bungalow, Mansion

Carter, Jimmy, and I carried out the door-to-door survey to collect the data. I carried out the analysis and compiled the map. Jimmy drew it, inked it, and laid down Zip-A-Tone screens for the grays. That map is reproduced in my book, *Home Rules*. Here we reproduce Jimmy's pencil drawing.

Stories

Carter, Jimmy, and I carried out the door-to-door survey to collect the data. I carried out the analysis and made the map in Illustrator.

Sidewalk Graffiti

The graffiti were collected by Susan Edwards and Helen Waldrop. Susan Edwards drew the map. I'm not sure who took the photograph.

Words

I made the rubbings in an effort to capture something of the neighborhood's truly unnoticed literature.

A Sound Walk

I made the little plan of the walk in Illustrator using Aurora's data. Aurora walked the neighborhood with a tape recorder and notebook to collect the sounds she displays here in a variety of Letraset and Zip-A-Tone patterns. The chart is the final step in an iterative process, each carefully checked against her field recordings.

Wind Chimes

Carter, Jimmy, and I collected these data during our door-to-door survey. I compiled the map and made it in Illustrator.

Radio Waves

I made the map using 1986 Arbitron ratings weighted by the results of a student survey carried out in 1975. A lot had changed in the intervening eleven years—including radio stations—but the comparison was a valuable way of confirming the relevance of the Arbitron rankings to Boylan Heights. These six stations accounted for more than half the listening audience. Transmitter locations for all radio stations are available online. I made the map in Illustrator.

Barking Dogs

Susan Edwards recorded the location of every barking dog in 1982 while learning mailman Tommy Rogers' route. I made the map in Illustrator.

Dogs

The data come from the 1975 survey I described in the note to Families. Among other intrusive questions, residents answered ones about pet ownership. I extracted the data from the questionnaires and made the map in Illustrator.

Viewsheds

To make this drawing, I stood at every intersection, and on tracing paper laid over U.S. Geological Survey topographic map *Raleigh West*, I ran lines out to the limits of what I could see.

I then traced the outline formed by these rays. I copied this onto a sheet of heavy dark paper and cut out the mask which I laid over *Raleigh West*. We made a number of versions of the map from this, and I subsequently recreated it in Illustrator without the underlying topographic map. This is an intermediate masked version.

Flowering Trees

Shaub Dunkley made the map.

Autumn Leaves

I walked through the neighborhood at the height of color in 1982 and used Prismacolor pencils to fill in a fine grid with the colors I saw. I smoothed this to a cruder resolution and used that as a template for typing the color names on the compositor. This is a recreation of that map in Illustrator.

The Age of Trees

Shaub Dunkley made this map, printing it as usual on the Tektronix 4662 flatbed plotter.

Trees by Size

Shaub Dunkley made this map, again, on the Tektronix 4662 flatbed plotter.

The Magic Tree Map Transformer Machine

Shaub Dunkley made all these maps. Carter or Aurora took the photograph on page 104 of the water oak at 901 South Street.

ACKNOWLEDGEMENTS

Dick Wilkinson, visionary head of the landscape architecture department at North Carolina State University, brought me to Raleigh in 1974. He also assigned me the studio my second semester in which this project was initially hatched. Arthur Sullivan, another visionary head of the landscape architecture department, supported the atlas project in 1982-83. All the students who worked on the project in its various incarnations earned my gratitude, but Aurora Dee, Susan Edwards, Shaub Dunkley, Tim Hess, Jimmy Thiem, Helen Waldrop, and especially Carter Crawford put me very deeply in their debt. Bill Bailey, who oversaw the production labs at the School of Design, was excessively helpful. My Boylan Heights neighbors suffered our intrusions from 1975 through 1986 with great, good humor.

The project was pushed under a table, ultimately into a bunch of boxes. There it languished until Ira Glass, host of Public Radio International's *This American Life*, when interviewing me on background in 1998 for a show he was doing on maps, asked if I myself made maps. The brilliant eight-minute segment he edited out of our two-hour conversation—often replayed—catapulted the atlas from boxes in a closet to the walls of museums and galleries on two continents, and intrigued authors, editors, and others. Among these was Xtine Burrough, whose desire to use the pumpkin map in her Digital Foundations series led me to discover Illustrator's potential for letting me finish the atlas myself. Another was artist Richard Kraft, who brought it to the attention of his wife Lisa Pearson, the peerless publisher of Siglio Press. There may well have been other paths to publication, but this is the one I've trodden, and I thank all who illuminated it.

I must also thank Ian Berry, Associate Director of the Tang Teaching Museum at Skidmore College for including the atlas in his important exhibition in 2001, *The World According to the Newest and Most Exact Observations: Mapping Art and Science*; Kitty Harmon whose publication of the pumpkin and newsletter maps in her seminal *You Are Here* brought the project to wide attention in 2004; John Krygier for publishing the atlas as completed on his *Making Maps: DIY Cartography* blog in 2008; and Julian Watson who included the atlas in *Place, Identity, and Memory*, an exhibition of art books that toured Scotland in 2009; among the others who opened their walls or their pages to the project.

More generally, I have to thank Irv Coats and Christine Baukus whose unflagging support for the past decade has made everything I've done possible. The debt is deeper in this case since their bookstore, The Reader's Corner, sponsors the Raleigh-area broadcast of *This American Life* (on the University of North Carolina's WUNC). Not the slightest bit incidentally, Christine drove me to the WUNC studios where Ira Glass interviewed me. Others who have provided essential support include John Fels, John Krygier, Tom Koch, Arthur Krim, Mitch Hazouri, Matthew Edney; and among Boylan Heights neighbors, Harriet Bellerjeau, Adryon Clay, Joseph Huberman, Carrie Knowles, Ray Lanier, Jeff Leiter, John Montgomery, Anne McLaurin, Charles Meeker, and Susan Perry. My sons, Randall and Chandler, endured my work on the project. Far more than anyone else, Ingrid Wood contributed to, encouraged, and put up with the atlas's massive intrusion into our lives in 1982-83. Thanks, Ingrid! Thanks, Randall and Chandler! Thanks everyone!